NORWICH AT WORK

SARAH E. DOIG

WITH PHOTOGRAPHS BY TONY SCHEUREGGER

AMBERLEY

ABOUT THE AUTHOR

S arah Doig was born in Hertfordshire, moving to Suffolk with her family at the age of one. She was brought up and educated in Bury St Edmunds, which she left to attend university. Sarah then found herself away from East Anglia for some twenty-seven years and, after having travelled the world during her twenty-year career in the Foreign and Commonwealth Office, she returned to live in Suffolk. She now works as a freelance local history researcher, writer and speaker. Sarah is the author of several East Anglian local history books including *A–Z of Cambridge* and *A–Z of Ipswich*, also published by Amberley. Other books include *The A to Z of Curious Suffolk* and *The Little History of* Suffolk. Sarah's website is at www.ancestral-heritage.co.uk.

First published 2020

Amberley Publishing
The Hill, Stroud
Gloucestershire, GL5 4EP

www.amberley-books.com

Copyright © Sarah E. Doig, 2020

The right of Sarah E. Doig to be identified as the
Author of this work has been asserted in accordance
with the Copyrights, Designs and Patents Act 1988.

ISBN 978 1 4456 8063 7 (print)
ISBN 978 1 4456 8064 4 (ebook)

British Library Cataloguing in Publication Data.
A catalogue record for this book is available
from the British Library.

Origination by Amberley Publishing.
Printed in the UK.

CONTENTS

INTRODUCTION

Norwich owes its success to its geographical setting. However, it is not by accident that the city is situated where it is, within a double bend of the River Wensum. Our early ancestors shrewdly chose a settlement site that had excellent communications by land and water. This allowed Norwich to develop from a small collection of Saxon farmsteads into the second largest city in medieval England, a rank it held until the Industrial Revolution changed the face of Norwich altogether.

Today, Norwich is the most complete medieval city in the United Kingdom. The construction of many fine churches was financed by the wealth generated by the textile industry. Strangers' Hall and Dragon Hall are two surviving, medieval examples of grand merchants' houses and the Guildhall bears witness to the dominance of the various city trade guilds. With the decline of the textile trade, Norwich workers turned their hand to brewing. Norwich also has a strong tradition of playhouses and theatres dating back to the early 1700s. The Theatre Royal, the largest and most successful theatre in the east of England, has often served as a testing ground for plays before they reach London's West End. The eighteenth century also saw the emergence of the footwear industry in the city. Many of the big names in the business, such as Clarks, Norvic and Bally, were based here. All that is left today are many of the magnificent red-brick factory buildings, now turned into office blocks or colleges. Twenty-first-century Norwich is mainly a service-based economy, hosting big names like Aviva and Archant. It is also home to ITV Anglia Television and the BBC's TV and Radio for East Anglia and Norfolk.

It is the Norman cathedral and castle that have dominated the city's landscape for centuries. In the intervening 900 years since their construction, businesses and industries have come and gone, testing the resilience of Norwich residents to the full. They have constantly had to adapt to changing world and internal markets for goods, and faced with competition from elsewhere, they have diversified and sought new ways of keeping the economy afloat.

In 2016, Norwich was voted by *The Guardian* newspaper as the happiest city to work in the United Kingdom. It is possible, then, that had such league tables been around in the Middle Ages, or in the Georgian or Victorian eras, the city would have fared just as well. In 1962, Sir Nikolaus Pevsner stated in his north-west Norfolk and Norwich volume of *Buildings of England* that 'Norwich is distinguished by a prouder sense of civic responsibility than any other town of about the same size in Britain' and it is that pride in their work that has driven Norwich residents to ensure its continued prosperity.

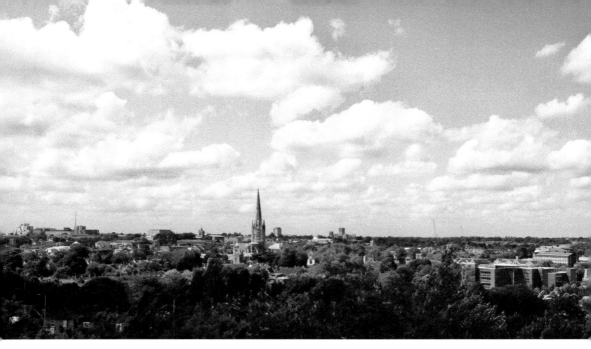

The view of Norwich from Mousehold Heath may have changed over the centuries, but the cathedral and castle still dominate the skyline. (Photo by Tony Scheuregger)

EARLY NORWICH

John Skelton, in his poem 'Lament for the City of Norwich', following two devastating fires in 1505 and 1507, sums up the status of early Norwich in the lines 'Norwich, so long the glory of our land.'

Much of the urban landscape of Norwich was shaped during the Middle Ages. Within a few centuries of the Norman Conquest of Britain in 1066, the Saxon settlement that was to become Norwich was transformed, with the construction, in 1120, of the castle keep on top of an earlier earth mound. Several early churches, as well as many homes, were swept away to make way for the cathedral, priory and precinct, which were founded in 1096. Then, in 1294, work started on the construction of the city walls, replacing the existing defensive bank and ditch. These formed two arcs to the west and south, and to the north. The River Wensum provided a natural boundary to the east, along which occasional defensive towers were constructed.

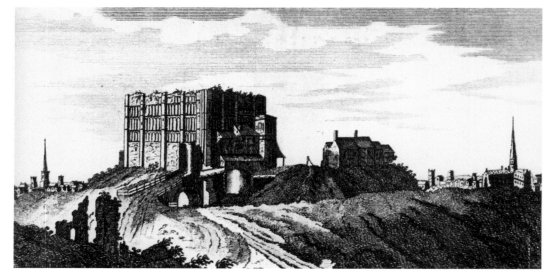

This eighteenth-century engraving of the city shows how the Norman castle has always loomed large.

In 1194, Richard I granted Norwich the right to self-government and so from this time on, the city authorities regulated the lives and livelihood of its inhabitants. By the early fifteenth century, before the Black Death wiped out up to a third of Norwich's population, around 25,000 people lived and worked within the city walls.

THE MEDIEVAL GUILDS

By the beginning of the fifteenth century, when a royal charter of 1404 established a merchant guild, all trades and occupations in Norwich were controlled by an elected council of freemen. A man, and occasionally a woman, had to be a Freeman of the City of Norwich to be able to carry out their trade. Construction of a Guildhall, which still stands today, began in 1407. This was used by the officials to govern the city, and remained the commercial and administrative hub through many centuries until the new City Hall was completed in 1938. Each trade had its own guild, which regulated the apprenticeship of boys to the craft and eventual acceptance by them as master craftsmen. Most guilds also took fees from members, which were then spent on supporting those tradesmen who were out of work or retired.

In total around 150 different crafts and trades were carried out in medieval Norwich. Around half the working population of the city was engaged in manufacture of some kind, with the leather and cloth trades dominating. Another quarter of workers provided food and drink. These included bakers, butchers, cheesemongers, millers and maltsters. Other residents were employed in the building trade or were part of the small artistic community,

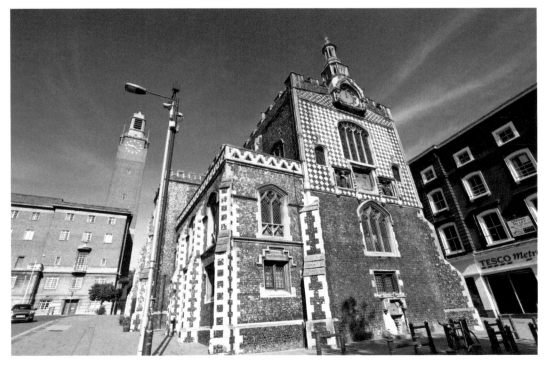

Norwich's Guildhall was the centre of city government from the early fifteenth century until 1938. The Assembly Chamber was designed for meetings of the full medieval council. (Photo by Tony Scheuregger)

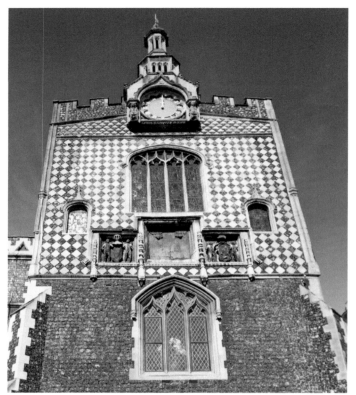

The Guildhall is the largest and most elaborate provincial medieval city hall in England. The chequered effect is created by using alternate squares of flint and stone. (Photo by Tony Scheuregger)

One prominent family of medieval bell founders were the Brasiers. One of their bells, thought to date from 1490, is now in the tower of St Julian's Church. (Photo by Tony Scheuregger)

ranging from makers of stained glass to musicians. There were also those employed in highly specialised skills such as goldsmiths, surgeons, apothecaries and bellfounders.

All workers in medieval Norwich, as elsewhere in the country, worked six days a week, having time off only on Sundays, significant saints' days and religious festivals. In 1422, the city authorities ordered that no one should open a stall or shop on a Sunday except for cooks, brewers and taverners.

Wealthy Norwich merchants, who often traded all manner of goods, built trading halls near the river. One of these was Robert Toppes, who exported Norfolk cloth and imported fine textiles, ironware, wines and spices. Dragon Hall was built by Toppes in the 1420s using some 1,000 English oak trees – he clearly wanted to impress his customers. At the rear of the building, Toppes created a yard space with access to the river for his imports and exports. He also constructed a warehouse area under the hall. Such merchants often occupied the senior positions in the city administration; John Toppes was elected mayor four times. Another mayor, John Asger, was a merchant who had moved to the city from Belgium. At this time, there were strong trading links between Norwich and Europe.

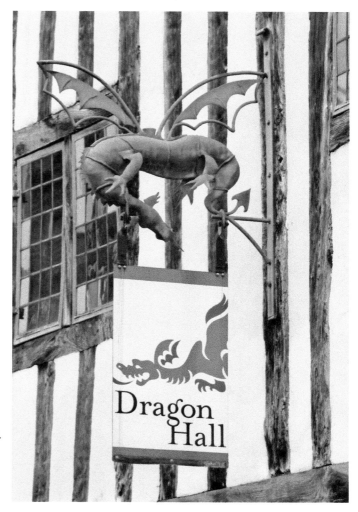

Dragon Hall is a rare example of a medieval merchant's trading complex. The main hall is decorated with fifteen dragons carved from Baltic oak. (Photo by Tony Scheuregger)

THE CLOTH TRADE

Textile production in Norwich grew steadily in the medieval era and remained the mainstay of the local economy for many centuries, until the Industrial Revolution saw a shift to the north of England. Early Norfolk weavers had developed a lightweight but strong woollen cloth called worsted. There was a plentiful supply of local wool in the area and the longer, thicker fibres were spun into worsted yarn, which was, in turn, used to weave the cloth.

Drapers, dealing in both woollen and linen cloth, had a prominent position in the marketplace. They bought local cloth from producers in and around Norwich. They would then have them dyed various colours before selling them either to individuals or to the merchants for wider distribution, including for export. One of the plants used to dye the cloth was madder and the present-day Maddermarket was the area of the city in which the plant was traded. The roots of the madder plant were taken to produce a red dye. Other plants available to medieval dyers included woad, a yellow-flowered plant which was a source of blue dye, and weld which produced a yellow colour.

The tower of the fifteenth-century St John's Church rises above the Maddermarket area where the madder plant was once traded. (Photo by Tony Scheuregger)

Linen, made from flax or hemp, was a sought-after luxury item in the thirteenth century but the number of Norwich linen drapers declined rapidly at the beginning of the following century due, in part, to the growth of the same industry in Flanders and the Low Countries.

It was the local wool trade that fuelled the building of large merchants' houses. Some of Norfolk's and England's best-known wealthy families had houses in the city, including the Pastons, Cokes, Boleyns and Howards. King Street, which runs parallel to the river, was particularly popular because the rear of the properties could have wharves and quays where the goods could be loaded and unloaded. Not all merchants wanted or needed waterside houses. The fourteenth-century merchant's house, now occupied by Cinema City, has been associated with many prominent Norwich citizens, including Robert Suckling, after whom the house is named.

As seen in neighbouring Suffolk, much of the wealth generated by the cloth trade funded the construction and enlargement of many of the fine churches in Norwich. In the medieval era it was said that there was a church for every week in the year, and probably a few more!

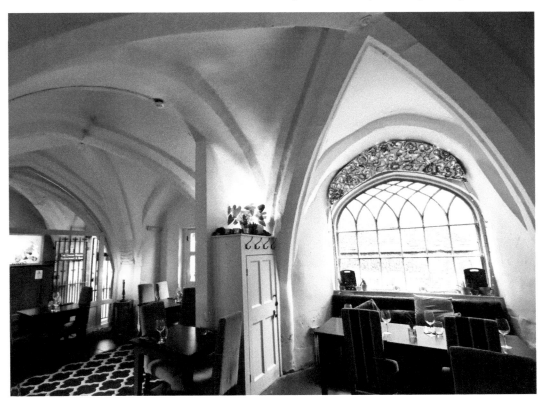

Suckling House is now used as a cinema, with its stone-vaulted basement providing a stunning venue for the restaurant. (Photo by Tony Scheuregger)

THE LEATHER TRADE

Tanners, leather dressers, saddlers and shoemakers all worked in leather, an important commodity in the Middle Ages.

Tanners cured the hides of cattle with bark and the poorer tawyers worked with sheep or goat skins, which they cured with oil or alum (a chemical compound). Before treating the skins, they were stripped of their hair, degreased, desalted and soaked in water over a period of days. It was a rather smelly process and was often relegated to the outskirts of town. However, in Norwich, many tanners operated within the city walls until moving to exploit the water supply in the river further out. This also meant that they were outside the control of the authorities. Leather dressers took the tanned leather and further enhanced its appearance and durability with oils, waxes and greases. They then sold the products on to those who manufactured goods from the leather.

Norwich's early shoemakers – also known as cordwainers – were the forerunners of the city's large footwear manufacturers of the nineteenth and twentieth centuries. These skilled workers produced both ready-made and bespoke shoes for their customers. Saddle and bridle making was a widespread industry in England and in Norwich these goods were sold on Saddlegate, now called White Lion Street. Like shoemaking, it was a skilled craft requiring many years of apprenticeship before being accepted as a master craftsman worthy of carrying out his trade.

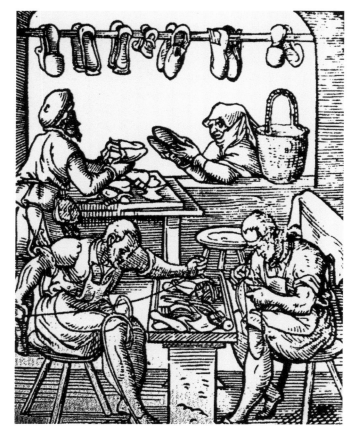

Cordwainers or shoemakers were skilled craftsmen providing made-to-measure and ready-made leather footwear.

THE FISH TRADE

Fish was a vital part of the medieval diet for rich and poor alike. Church rules forbade the eating of meat on certain days of the year, including during Lent, and so fish was always in demand. Norwich was an important centre for the herring trade in the early Middle Ages. The herring were caught off the east coast and brought into Great Yarmouth where they were transported by river into Norwich. Access to the wharves and quays in the centre were strictly controlled. The Boom Towers, which allowed a barrier to be lowered between them, regulated river traffic.

These wharves and quays in the city centre were once teeming with boats and people, unloading herring and other saltwater fish, as well as freshwater species. (Photo by Tony Scheuregger)

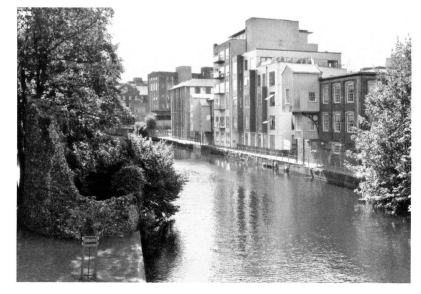

The remains of one of the Boom Towers, near Carrow Bridge, between which a barrier could be lowered. (Photo by Tony Scheuregger)

Freshwater fishing was undertaken along the city's stretch of river, which was divided up into sections leased out to fishermen. As early as the fourteenth century, there were concerns about stock levels and the authorities issued regulations. They included a ban on drag nets except during August and September. When drag nets were used, they were to have a stone weighing less than 2 lbs.

THE MARKET

The market in Norwich has been the centre of both trade and administration since very earliest times. Before the Norman Conquest, the market was in Tombland. Rather than having any association with graves, the name Tombland comes from two Old English words meaning an open space. When the Normans built the castle, the market was moved to its present site, where those in the castle could keep a closer eye on commercial transactions.

This Great Market soon covered a huge area with rows of permanent stalls. Each set of stalls was designated for certain trades with the fishmongers rubbing shoulders with the butchers, and the skinners with the drapers. The main marketplace became so crowded that subsidiary markets developed, many of which are reflected in modern-day street names. The Haymarket was where cattle, sheep, poultry and wheat were sold. Horses were traded outside St Stephen's churchyard near what is now Rampant Horse Street and the pig market was originally held on All Saints Green before moving to Hog Hill (Orford Hill).

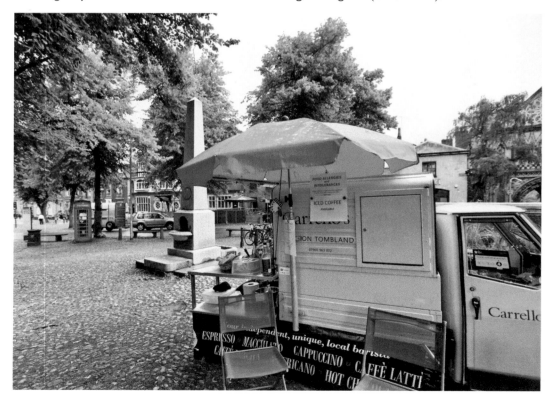

Tombland, now home to a mobile coffee business, was the marketplace in pre-Norman times. (Photo by Tony Scheuregger)

It is thought that in the Middle Ages, the market was held on Wednesdays and Saturdays, although a daily market was held for a brief period. An area below the permanent stalls was set aside for country smallholders who were able to sell cheese, eggs, pots, pans, knives and candles. The city authorities oversaw all stallholders' activities and taxed their income. They ensured that products were of good quality and that underweight food was not sold. Those guilty of flouting the regulations were often fined and put in the stocks.

The Church of St Peter Mancroft overlooks the present-day market, as it has done for nearly 600 years. It was financed with gifts and legacies from wealthy citizens, as well as donations from merchant and craft guilds. It still continues to have close links to the market. Historically, all stallholders have the right to be married and buried in the church.

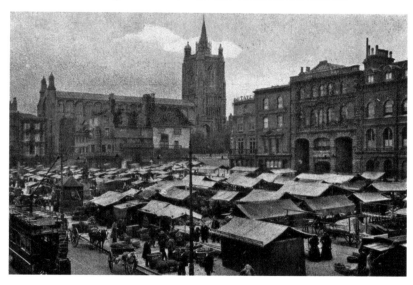

An early twentieth-century postcard of the marketplace suggests how little it had changed since the Middle Ages; much of the produce and goods would also have been the same.

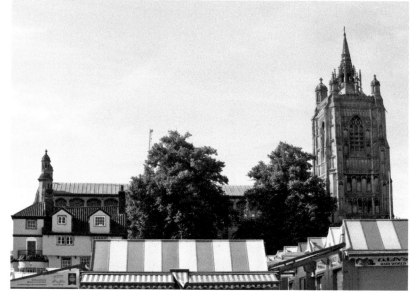

St Peter Mancroft towers over the marketplace, providing spiritual support for the traders as it has done for centuries. (Photo by Tony Scheuregger)

TUDOR AND STUART NORWICH

During the sixteenth and seventeenth centuries Norwich was undoubtedly the second most important city in England after London. This was recognised at the very start of the Tudor era with a visit from the new king, Henry VII, in 1485. In the first decade of the 1500s, the city was devastated by three fires, which destroyed hundreds of houses. Elm Hill, one of the best-preserved parts of Norwich today, was almost completely rebuilt after the fires, which allowed for construction of the then modern jettied houses with pantile roofs. Many prosperous merchants, master craftsmen and civic dignitaries had houses there.

The Tudor period was a time of great change for religion in the city. Following Henry VIII's break from Rome and the creation of the Church of England, Norwich's four friaries were dissolved or surrendered to the Crown. This led to a power shift in favour of the city authorities, which, in turn, was briefly halted by the famous Kett's Rebellion of 1549. Soon

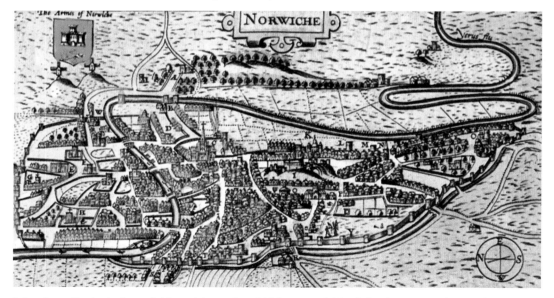

John Speed's depiction of Norwich on his 1610 map of Norfolk shows an already large, thriving city.

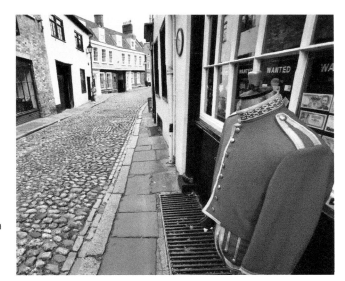

The properties on either side of the cobbled streets of Elm Hill were built in the sixteenth century, replacing earlier fire-ravaged ones. (Photo by Tony Scheuregger)

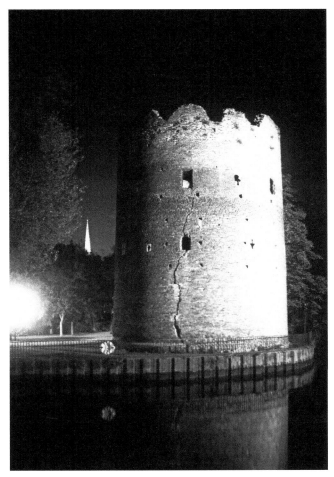

Cow Tower was rebuilt in 1399 as part of the city's defences. It had previously been used as a prison and for the collection of river tolls. (Photo by George Plunkett)

afterwards, in 1556, a new royal charter was granted to Norwich. It defined the boundaries of the city for the first time, taking in areas beyond the city walls. This solved the problem of how to deal with trades and craftsmen living and working outside the walls. It meant that they were now able to buy and sell goods, alongside those who had properties within the walls, in the closely regulated city.

It was the textile industry that allowed Norwich to grow in wealth, importance and population through to the 1700s. After his visit in 1681, Thomas Baskerville wrote 'it is a great city and full of people' and in 1698, Celia Fiennes described it as 'a rich thriving industrious place'.

THE STRANGERS

The continued success of the textile industry in Norwich can, to a large extent, be attributed to the arrival of the 'Strangers'. Norwich had suffered an economic downturn in the mid-sixteenth century. One factor was the success of lighter, foreign fabrics known as New Draperies, which competed in the market against Norfolk's worsted cloth. These new fabrics included lace, ribbons and stockings. Local leaders, including the Duke of Norfolk and the Mayor of Norwich, Thomas Sotherton, came up with an idea to invite master weavers from the Low Countries to settle

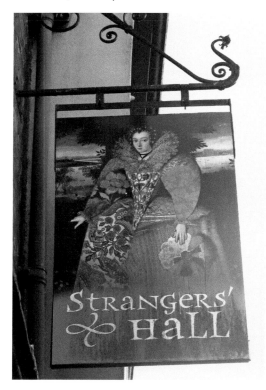 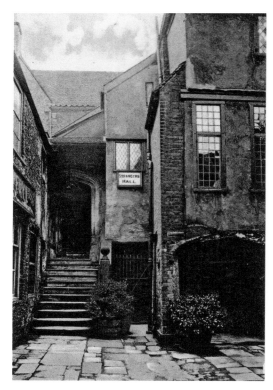

Above left: The current sign hanging outside Strangers' Hall tells us how the incomers from the Continent contributed to the success of Norwich's textile industry. (Photo by Tony Scheuregger)

Above right: A postcard dating from around 1915 shows the inner entrance courtyard of Strangers' Hall.

A companion postcard depicts the heavy oak door that dates back from before the arrival of the Strangers in Norwich.

in Norwich. So, in 1566, twenty-four Dutch and six French-speaking, Walloon master weavers arrived in Norwich with their families, apprentices and servants. Many more followed over the next few years and by 1579, there were 6,000 Strangers in the city out of a total population of around 16,000. Strangers' Hall on Charing Cross, a grand merchant's house dating back to 1320, was where Mayor Sotherton lived and its present-day name comes from the fact that some of the foreign newcomers to the city may well have lodged with him. It is now a museum, which recreates the life for inhabitants of the house throughout its history. Although some Strangers were wealthy, many more were relatively poor.

Not all of Norwich's Strangers were weavers. The first printing press in the city was established by a Dutchman called Anthony de Solempne. The skilled craft of silversmithing was also given a boost by Strangers such as George Fenne, Valentine Isborne and Zachary Shulte. Others worked in the building industry or as brewers, schoolteachers, doctors, bakers and potters. The Dutch speakers also brought with them a love of gardening, introducing new flowers and plants, as well as new growing methods. From at least the 1630s onwards, Florists' Feasts took place in St Andrew's Hall. These events were the Chelsea Flower Show of the era!

The Norwich tradition of breeding canaries was also introduced by the Flemish weavers. The celebrated Norwich Plainhead Canary was bred and sold as far away as London and the

St Andrew's Hall hosted the seventeenth-century equivalent of the Chelsea Flower Show, as well as providing a place for services for the Dutch community. (Photo by Tony Scheuregger)

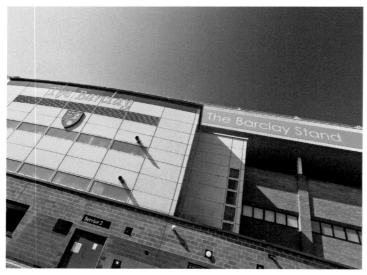

Norwich City Football Club proudly displays a yellow canary on its shield, a nod to the Flemish weavers who first bred the birds in the city. (Photo by Tony Scheuregger)

bird's clear orange-yellow colour is thought to have come from feeding the birds cayenne pepper during moulting.

The Strangers' presence in Norwich was controversial and threatening for some who thought that their own livelihoods were at risk of being eclipsed by these foreigners with new ideas and methods. So much so that in 1571 strict controls were introduced by the city authorities on the manufacture of textiles by the Strangers. Inspections were introduced of every piece of fabric produced and those producing substandard goods were fined and the cloths destroyed. There was also much competition between the Dutch- and French-speaking communities. Each community manufactured a different kind of cloth. The Walloons produced

Above left: The bricked-up tower of the once busy St Mary-the-Less Church in Queen Street. French weavers worshipped here. (Photo by Tony Scheuregger)

Above right: The Strangers Club in Elm Hill was founded in 1927 with the intention of entertaining the many 'strangers' to Norwich, just as their forebears had done some 350 years earlier. (Photo by Tony Scheuregger)

dry-woven cloth known as caungeantry. The Dutch were only allowed to make baytrie, a weave produced from wet, greasy fibres.

Religion was important to the Strangers. The main reason for their willingness to move to England was the persecution, in their home countries, of those who followed a Protestant faith. Each community had its own church and so the Dutch and French speakers worshipped separately. The Dutch held services in St Andrew's and Blackfriars Halls. They also used St Peter's Hungate for a while. The French first worshipped in the chapel of Bishop Parkhurst but later moved into St Mary-the-Less in Queen Street.

TEXTILES

When the diarist John Evelyn visited Norwich in 1671 he wrote: 'The fabric of stuff brings a vast trade to this populous town'. Indeed, the number of freemen working in the textile industry who were admitted to the merchant guilds had increased from just one in seven in the 1570s to around one in two a century later. Even so, because Norwich sat in the heart of an agricultural region, all worsted weavers were required to leave off work for a month to help during harvest time.

Part of the continued growth of the cloth industry was due to better regulation by the authorities. In 1613, a set of rules were drawn up to monitor every aspect of the Norwich textile sector. Before then there were constant complaints of workers evading apprenticeship,

shoddy goods being produced and falsification of measurements. Acts of Parliament in 1650 and 1672 further protected cloth workers' livelihoods. A seventeenth-century broadside, an early form of newspaper, shows worsted weavers dancing around a bonfire onto which they are throwing cheaper, foreign, imported cloth that had been threatening the British industry. They are giving thanks for king and parliament for saving their jobs. Smaller images either side show the range of textile-related work, as well as other industries, that were sustained by worsted manufacturing. These range from woolcombers, spinsters, property landlords and alehouse keepers.

The success of the textile industry brought with it a rapid increase in the population of Norwich. The large houses of the gentry rubbed shoulders with those properties occupied by less prosperous neighbours. In Colegate, Henry Bacon, a rich merchant dealing in worsted who served as Sheriff and Mayor of Norwich in the mid-sixteenth century, built an impressive residence. Just along from this house are some of the last surviving seventeenth-century weavers' cottages. The occupants would have operated their hand weaving looms in the attic rooms where full-height dormer windows were designed to let in as much light as possible. Soon there was no room for more houses within the city for the working classes without encroaching on the green spaces, and so large houses were subdivided and smaller dwellings were constructed in the courtyards behind the properties. These were accessible through an arch or passageway and this accommodation was used right the way through to the early twentieth century when most were demolished.

In the seventeenth century, Norwich was the leading centre outside London for the manufacture of starch. The fashionable ruffs and collars of the day required constant stiffening with starch, which was made from bran. Despite complaints about the use of wheat for such vain purposes, while others in the country were starving for lack of bread, the starch industry flourished.

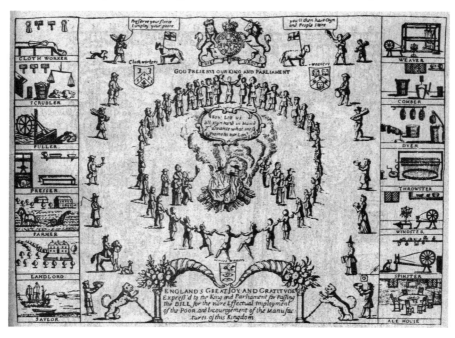

An illustration from a seventeenth-century newspaper shows all the main textile-related activities, as well as those supported by the industry.

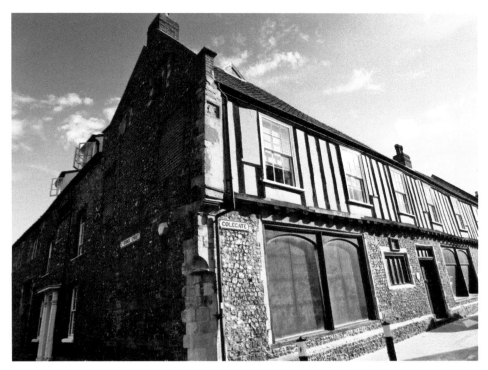

Henry Bacon built an opulent house on Colegate. The extensive property provided space for all his mercantile activities. (Photo by Tony Scheuregger)

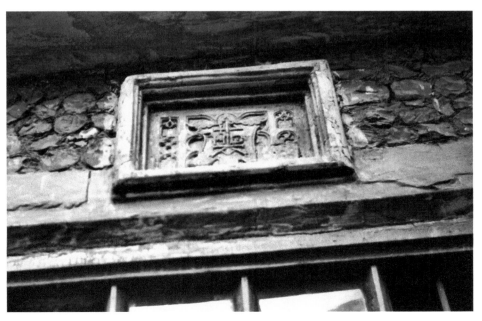

Henry Bacon's merchant's mark, incorporating his initials, appears several times on this well-preserved Elizabethan house. (Photo by George Plunkett)

A former weavers' cottage on St Andrew's Hill, photographed in 1936, shows the narrow line of windows towards the top of the property. (Photo by George Plunkett)

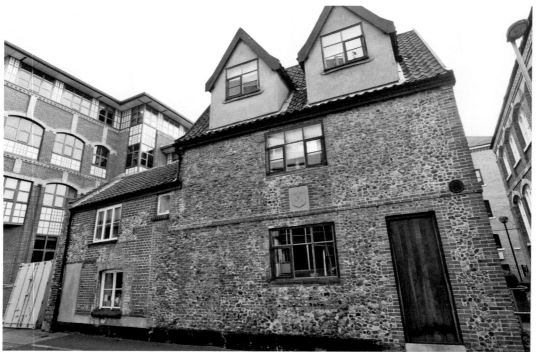

A surviving example of a weavers' cottage in St George Street. The inhabitants would have worked on the top floor where light flooded in from the large windows. (Photo by Tony Scheuregger)

Burrell's Yard in 1937, one of the many yards or courts. The small dwellings were accessed through a narrow passageway from Colegate. (Photo by George Plunkett)

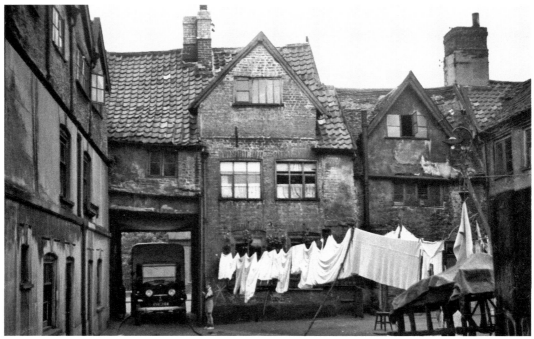

An archway led into Old Brew Yard, one of several yards behind Oak Street. Many of these yards were condemned and demolished shortly after this photo was taken in 1937. (Photo by George Plunkett)

CULTURE AND COFFEE

Towards the end of the Stuart period, the number and range of shops in Norwich became much greater. There were a number of booksellers in the centre of the city whose businesses were thriving due to the growing number of people who could read, devouring books on almost every subject imaginable including poetry, religion, gardening and cookery. Even joke books took their place alongside novels.

The first coffee house opened its doors in Norwich in 1676 and other establishments quickly followed. Some were situated around the marketplace, while the city corporation rented out part of St Andrew's Hall to be used as a coffee house. These shops were where people could go to access printed news for the first time.

We know there were regular visitors to Norwich from elsewhere in the country, no doubt taking advantage of the wide range of shops and markets. Stagecoach services had begun in the mid-seventeenth century and one of the major routes was from London to Norwich. The city's coaching inns, such as the Castle, the Duke's Palace and the Maids Head, all took advantage of this new form of transport, providing rest and shelter for both travellers and their horses. In March 1762, a coach service started between the Green Dragon in Bishopsgate, London, and the Maids Head. It had space for four passengers inside, who paid 25 shillings each. Those passengers who were prepared to ride on the outside of the coach were charged at half the inside rate. It proved so successful that a larger coach was built and the fares reduced.

Coffee houses are once again popular in Norwich. This one is housed in a property that predates the arrival in the city of such establishments. (Photo by Tony Scheuregger)

The Maids Head embraced the age of the stagecoach. In 1785, it had stables that would hold around 100 horses.

GEORGIAN NORWICH

The eighteenth century witnessed a period of wealth for Norwich residents, with the population rising only modestly to around 37,000. The city's prosperity was due to the continued growth in its importance as a textile manufacturing centre. This prosperity gave rise to a programme of civic building. The Shire House, a lunatic asylum, hospital, library, the Assembly House and a county gaol on the castle mound were all constructed in the 1700s. Private residents renovated old properties, cladding the exterior with thick brick tiles to emulate the new building fashions. Those who could do so built new houses in the grand Georgian style. The rise of nonconformity in Britain as a whole was embraced by Norwich; the Baptist chapel and the Octagon chapel were two new meeting houses built in the mid-eighteenth century.

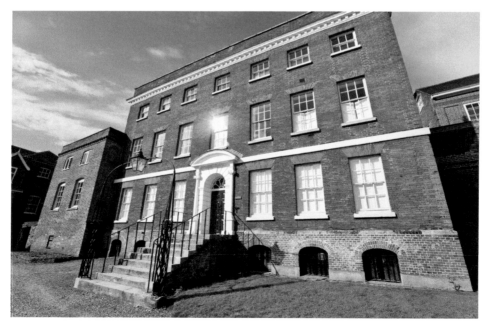

One of the many fine Georgian houses in The Close near the cathedral. This one is now home to the Norwich School. (Photo by Tony Scheuregger)

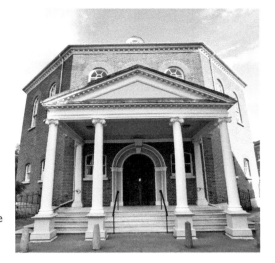

The Octagon chapel, originally built for the Presbyterians, was completed in 1756 by the architect Thomas Ivory, in the English neo-Palladian style. (Photo by Tony Scheuregger)

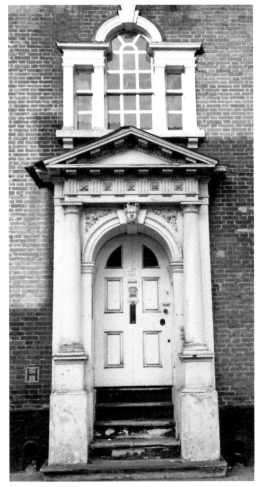

No. 44 Magdalen Street, with its Venetian window above the door, is one of the most ornate Georgian houses in the city. It has, however, seen better days. (Photo by Tony Scheuregger)

There were also notable improvements in communications, and therefore the prospects for trade. The river network was significantly improved for larger boats, so much so that by the end of the 1700s, more than half the total output of the textile industry was being exported by river. The roads were also being improved, with Turnpike Trusts being set up across the country aimed at financing the maintenance of the main coach routes.

A 1783 trade directory shows that Norwich was becoming more than ever a city of shopkeepers with forty grocers, thirty butchers, sixty bakers, thirty drapers and mercers, twenty-four hosiers, hatters and milliners, twelve booksellers and six chemists. Around 13 per cent of all those with business interests were women.

NORWICH WORSTED

The Norwich worsted trade grew rapidly in the eighteenth century. It was this wool trade that kept the city's economy so strong. With a population at the start of the century of some 30,000, Norwich was still the second largest city in England. A range of new fabrics were developed, some of which were made from pure worsted and some from a worsted and silk mix. Norwich cloths had powerful champions such as Robert Walpole, Britain's first prime minister, who ensured that court mourning dress was made from Norwich crepes. There was a countrywide ban on importing printed cotton cloth from overseas and for fifty years or so, it was even illegal to wear it!

In the 1720s, the author and journalist Daniel Defoe visited Norwich as part of his tour of Great Britain. He recorded: 'If a stranger was only to ride through or view the city of Norwich for a day, he would have much more reason to think there was a town without inhabitants; but on the contrary if he was to view the city, either on a Sabbath-day, or on any public occasion, he would wonder where all the people could dwell, the multitude is so great. But the case is this: the inhabitants being all busy at their manufactures, dwell in their garrets at their looms, and in their combing shops, twisting-mills, and other work-houses, almost all the works they are employed in being done within doors.' These workers were, largely, the employees of the master weavers who were able to afford to build new residences in the grand Georgian style.

The Harvey family were textile merchants who needed a home which doubled-up as a showroom, workshop and warehouse, much the same as their medieval predecessors. The Harveys made their fortune trading in 'Norwich stuffs', cloth with elaborate patterns. They exported to the Far East and South America, as well as to most of Europe.

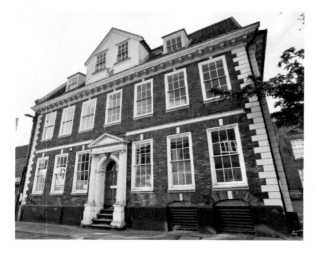

No. 18 Colegate is a grand Georgian town house built by the wealthy Harvey family of textile merchants. It is where they lived and did business. (Photo by Tony Scheuregger)

It was only in the late 1700s that the Norwich worsted trade began to decline. This was due, in part, to England fighting a war with the American colonies and then with France, which hit the export trade hard. However, Norwich master weavers were also reluctant to introduce newly invented machinery as they did not want to upset their workforce who were used to hand-making the cloth. Therefore, they found that they could no longer compete with the large-scale, water-powered mills in Yorkshire.

BALLS, PLAYS, CONCERTS AND OPERAS

By the start of the eighteenth century, Norwich society had a sizeable group of individuals who considered themselves the so-called 'middling sort'. They comprised tenant farmers, tradesmen and shopkeepers and they had both money and leisure time with which they wanted to enjoy themselves. Norwich therefore became one of the foremost entertainment venues in the country.

In 1754, architect Thomas Ivory redesigned an existing building for use as an entertainment centre for assemblies, concerts and dances. This Assembly House also hosted educational lectures in subjects as diverse as astronomy and the decorative arts. In December 1805, a grand ball, attended by some 450 ladies and gentlemen, was held to celebrate Admiral Nelson's victory at Trafalgar. Touring exhibitions such as Madame Tussaud and her waxwork figures were also hosted at the Assembly House. Today, the complex of buildings still presents art exhibitions, concerts and plays.

A few years after the Assembly House opened its doors, the same architect designed and built only the second purpose-built theatre in England. The two buildings sat alongside one another near Chapelfield. The theatre received royal assent in 1768 and was from then on known as the Theatre Royal. It was remodelled and enlarged in 1801 and since then it has undergone several further transformations. Over the years, many well-known acts have played in the theatre including Tom Thumb, the violin virtuoso Nicolo Paganini, and the Bolshoi Ballet.

Building on the centuries-long reputation of the Theatre Royal, other theatres have appeared such as the Norwich Playhouse, which opened in 1995 in a former eighteenth-century maltings. Some people were surprised that the Playhouse does not have Georgian origins but many more are fooled by the Maddermarket Theatre, a former Roman Catholic chapel that, in the 1920s, was transformed into a recreation of an Elizabethan theatre. An

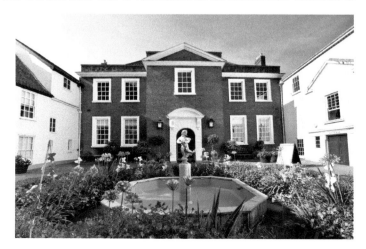

The Assembly House has provided a venue for concerts, balls, exhibitions and plays for nearly 300 years. (Photo by Tony Scheuregger)

even more dramatic structure, the former Norwich Hippodrome, has completely disappeared from St Giles Street. It started life as an opera house and playhouse in 1903 and contributed to the city's centuries-long tradition of hosting national and international stars.

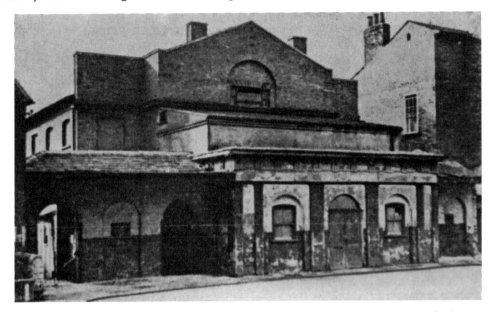

The first Theatre Royal in Norwich was built alongside the Assembly House. Such was its success that it was substantially enlarged less than fifty years later.

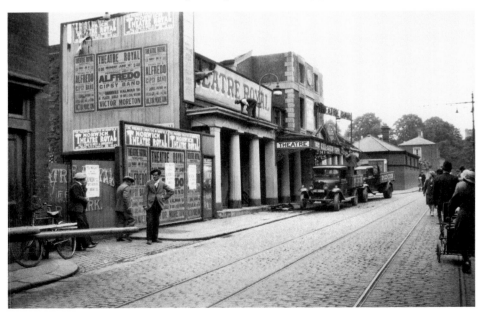

The second Theatre Royal building, photographed here in June 1934 after it was destroyed by fire. (Photo by George Plunkett)

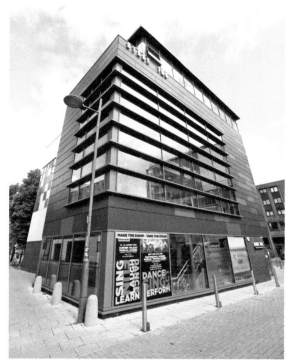

In 2016, Stage Two opened its doors, providing a home for the Theatre Royal's own Youth Theatre Company. It also offers theatre arts courses. (Photo by Tony Scheuregger)

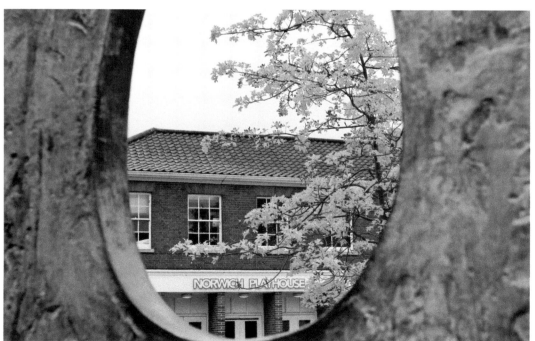

The Norwich Playhouse opened in the late twentieth century and is housed in a former maltings. (Photo by Tony Scheuregger)

The Maddermaket Theatre was home to the Guild of Norwich Players and, for the last century, has hosted plays, concerts and comedy. (Photo by Tony Scheuregger)

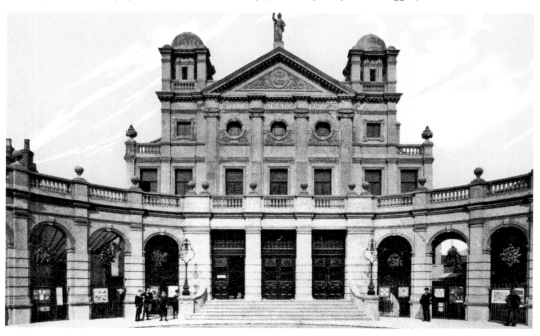

A multistorey car park now occupies the space where this magnificent Grand Opera House, pictured here at the turn of the twentieth century, once stood.

HEALTH

The Georgian era saw many hospitals spring up across the country, most supported by private donors and public subscription. These provided not only much-needed medical facilities for residents but also new employment. In Norwich, the Bethel was built in 1713, financed by Mary Chapman, the widow of a local clergyman. She had relations affected with mental illness and was concerned that such people, especially the poor, were treated like outcasts. The Bethel Hospital was therefore established as a home for incurable lunatics who were citizens of Norwich and too poor to pay for their own treatment in private institutions. Many prominent residents of Norwich gave generously to the Bethel, which allowed it to support inpatients with mental health problems right through to the 1970s.

The Norfolk and Norwich Hospital also has an impressive track record and it is William Fellowes who is credited with establishing a subscription fund in 1771 for a new general hospital in the city. Three acres of land just outside St Stephen's Gate were leased and a prominent local architect, William Ivory, appointed as architect. Just two years after the appeal for donations, the first patients were admitted. At first, the charity received only patients recommended by subscribers as being too poor to pay for medical treatment elsewhere, although urgent assistance was available at a rate of 1 shilling per day. Later, other patients were able to access the facilities if they paid a contribution towards their treatment. The Norfolk and Norwich went from strength to strength and its direct successor, the Norfolk and Norwich University Hospital, occupies a new site on the outskirts of the city.

The residents of Georgian Norwich also benefitted from the springing up of pleasure gardens. It was one of a handful of cities in England where the rising 'middling sort' could enjoy these open spaces for walking and recreation. In 1739, John Moore designed New Spring Gardens as a place where ladies and gentlemen could promenade, take a pleasure boat ride or enjoy wines, cider, cakes and ale. The garden was illuminated at night and guests were entertained with music and fireworks. Another of Norwich's public gardens was the Wilderness which was, as the name suggests, a more natural landscape resplendent with clockwork sheep!

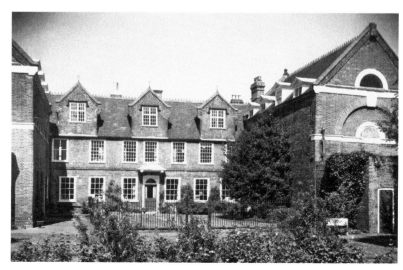

Built in 1713, the Bethel is one of the oldest psychiatric hospitals in the country. (Photo by George Plunkett)

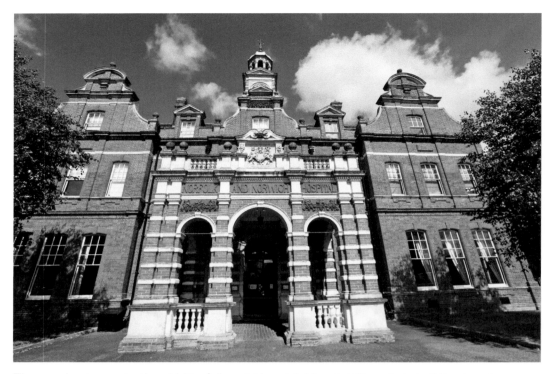

The grand entrance to the old Norfolk and Norwich Hospital. The whole building has since been converted into residential units. (Photo by Tony Scheuregger)

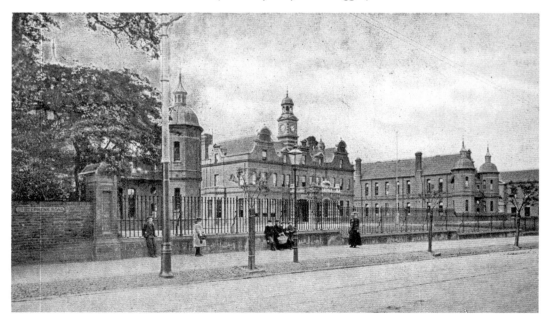

When it first opened, the Norfolk and Norwich Hospital only treated those too poor to pay for medical care elsewhere. They were supported by a subscription fund.

The original Norfolk and Norwich Hospital buildings were extended to provide homes for medical staff. (Photo by Tony Scheuregger)

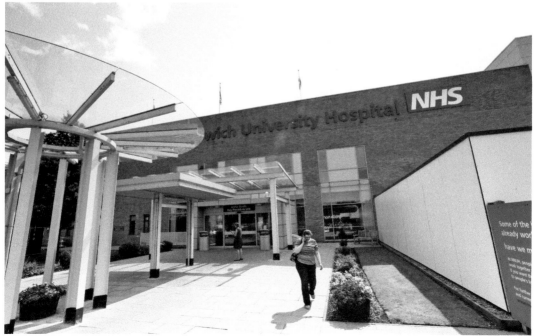

The new hospital, on the outskirts of the city, is a university teaching hospital and treats nearly one million outpatients every year. (Photo by Tony Scheuregger)

BANKING AND INSURANCE

The eighteenth century saw the emergence of banking and insurance in Norwich. The first bank in the city was founded in 1756 in the marketplace and was that of Charles Weston, a brewer. This was followed by a couple of others, but by far the most prominent and successful was that established by the Gurney family. The Gurneys were Quakers and, on their move to Norwich in the 1600s, were originally involved in the woollen trade. They gradually moved into banking transactions and, in 1770, they founded Gurney's Bank in Tooley Street (now Pitt Street). They soon moved into larger premises in Redwell Street, which is now called Bank Plain after the famous financial institution. The premises had been the property of a wine merchant and the former wine cellars became the bank's vaults. This Quaker bank became renowned for its honesty, reliability and fair dealings, which meant that people were happy to entrust the Gurneys with their money. By 1782 they had branches in King's Lynn and Wisbech, as well as in Halesworth in Suffolk. The family married into the Barclay family of London and Gurney's played a key role in the growth of Barclays Bank into a nationwide concern.

In the early 1700s, London fire insurance companies had used Norwich agents for their business. It was not until 1792 that the city had its own insurance firm: the Norwich General Assurance Company, which was set up by Thomas Bignold, a wine merchant and banker. Bignold is said to have tried to insure his luggage for his move to Norwich from Kent but had been told that this kind of insurance did not exist. He replied, 'There is nothing that is uninsurable, the question is merely would those who would fain be insured pay the price?' In 1797, Thomas Bignold founded the Norwich Union Fire Office with support from local shopkeepers. He appointed 500 local agents who helped him to expand the geographic coverage of the business. Growth was also driven by his practice of offering profit sharing to fire insurance policy holders. This success was followed nine years later by the opening of a life insurance office. All these firms merged in 1821 and the resulting combined business became known as Norwich Union (now Aviva).

 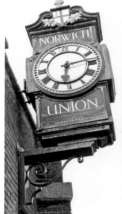

Above left: Bank Plain in Norwich is named after one of the first such financial institutions to be established in the city by the Gurney family.

Above right: The Norwich Union clock in Surrey Street gives the date of its foundation as 1797. Today, Aviva can trace its roots back to 1696. (Photo by Tony Scheuregger)

VICTORIAN NORWICH

During the 1800s, the population of Norwich rose steadily but not at the speed of comparable cities in the north of England. Norwich had around 37,000 residents in 1801 and just over 100,000 in 1891. In the first few decades of the nineteenth century through into the beginning of the reign of Queen Victoria, Norwich suffered the collapse of its weaving industry. Indeed, G. M. Young, in his *Early Victorian England*, commented that it 'was formerly a great manufacturing city; but it has declined much of late'. The final mill to be built in Norwich, St James' Mill, now arguably the most spectacular industrial monument in the city, was opened in 1839 in an unsuccessful attempt to compete with the new Yorkshire weaving factories. However, other parts of the textile industry continued to flourish, including the making of printed 'Norwich shawls', which were widely exported overseas. A number of Norwich master weavers of shawls exhibited their work at the Great Exhibition of 1851.

St James' Mill was constructed by the Norwich Yarn Company in an attempt to compete with the new Yorkshire mills. (Photo by Tony Scheuregger)

Not all industries suffered the same fate as the textile trade. Brush making was one main employer in Norwich throughout the Victorian period. By 1890, there were at least fifteen brush makers in the city, including Cooks, established in 1814, which had a shop in Davey Place. In its catalogue, the firm proudly announced 'Many so-called new industries have not destroyed the old, but have only roused the old city to fresh activity, and have shown new and unexpected vigour. Craftsmen long dead still live and the products of today travel the highway, north, south, east and west.' Other industries prospered such as brewing and the era also saw the arrival of several family firms that were to become household names and who ensured that Norwich remained firmly on the economic map.

One of the Norwich shawl exhibitors at the Great Exhibition was Edward Blakely. His designs were described as 'it is everything to be desired'.

Photographed in 1983, this derelict brush factory in St George Street was built in 1867. Like many former industrial buildings, it is now apartments. (Photo by George Plunkett)

TRAINS AND TRAMS

The coming of the railway to Norwich was an obvious godsend to industry and commerce in the city. The first station, situated in the then village of Thorpe, was opened in April 1844 with regular passenger services running between Norwich and Great Yarmouth. This was quickly followed by a route to London via Cambridge and Bishop's Stortford. With traffic growing, it was apparent a new station was required in Norwich and so one was built at a cost of £60,000 to the north of the original station, opening in 1886, and is the structure surviving today as the only remaining Norwich station. The old terminus became part of the expanded goods facilities.

In 1849, Norwich Victoria station opened at the southern end of St Stephen's Street, which allowed passengers to travel to and from London via Ipswich. This continued until 1916 when it operated goods services only until its demolition in the 1970s. Norwich City station opened half a mile north-west of the city centre in 1882. This building was bombed in the Second World War and a temporary structure constructed, which served lines to Cromer and destinations in the East Midlands until the mid-twentieth century.

In the second half of the eighteenth century, Norwich's residents increasingly occupied its suburbs. So, in 1879, a horse-drawn bus service was introduced, enabling workers to

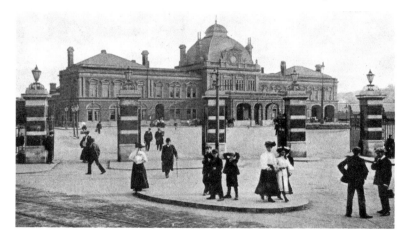

Even in Edwardian times, Norwich station was a busy place, used by commuters and tourists alike.

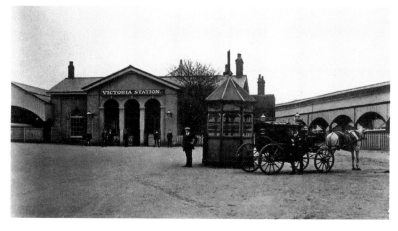

Norwich Victoria station was opened by the Eastern Union Railway, which operated regular passenger trains to and from London.

access their workplaces and shoppers the city centre. Soon after this was wound up, Norwich Electric Tramways began laying rails and the first tram services started in 1900. At its peak, the firm had over forty trams covering a wide suburban network. The trams' popularity waned with the advent of motor bus services and the last tram in the city ran in December 1935.

Norwich City railway station, pictured here in the early 1900s, was the southern terminus of the Midland & Great Northern Joint Railway.

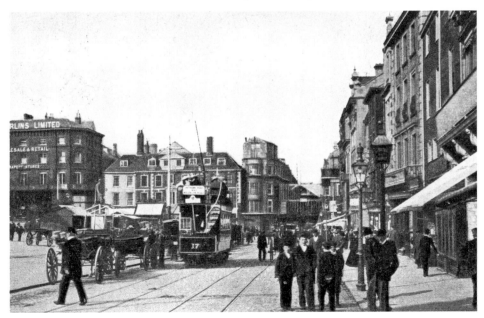

There were ten main tram routes in total. Open-top, double-decker tram cars brought commuters and shoppers into Gentleman's Walk from Earlham Road and Unthank Road.

BREWING

Brewing in Norwich has a long and distinguished history, but it was in the Victorian era that the industry boomed. In 1783, there had been nine breweries in the city but in 1836 there were twenty-seven. As a result of this high number of large brewing concerns, there was a smaller percentage of pubs brewing their own beer in Norwich than anywhere else in England.

One nineteenth-century newcomer was John Youngs, who set up his Crown Brewery on King Street in 1807. The business expanded fast and by the middle of the century, it had around 100 tied public houses due to a successful partnership with John Crawshay. When the founder's son joined the firm it became Youngs, Crawshay & Youngs and the brewery was expanded. In the 1930s it used the slogan 'Beer is best, gives life zest: Youngs & Crawshays lead the rest.'

The Conisford Brewery, later known as the Old Brewery, was also in King Street. It had probably existed in some form for some three centuries before brothers John and Walter Morgan bought it, along with fifty-four public houses. Morgan's subsequently took over a number of other breweries in Norfolk, resulting in a portfolio of over 600 tied houses by the early 1900s.

The Peacock public house in St Stephen's Plain, photographed before its demolition in 1900. It proudly declares that the pub offers Youngs, Crawshay & Youngs' fine ales and London Stout.

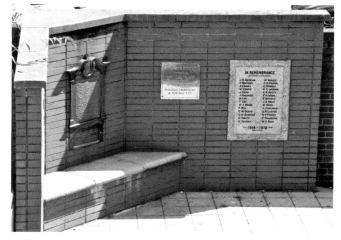

Off Kilderkin Way, once the site of Morgan's brewery, is this war memorial commemorating employees of the breweries who lost their lives in various conflicts. (Photo by Tony Scheuregger)

The Pockthorpe Brewery of Steward & Patteson Ltd was largely demolished in the 1970s but the now renovated old brewery offices stand as a reminder of this once great brewery. At its peak, after having taken over several other East Anglian concerns, their estate comprised 1,250 pubs.

The last of the big breweries to emerge at this time was Bullard & Sons Ltd. The firm began as the Anchor Brewery when Richard Bullard teamed up with James Watts in 1837. The partnership was dissolved ten years later, and Bullard carried on alone, with his son continuing after his death. By the end of the nineteenth century, the brewery occupied substantial red-brick, riverside buildings covering an area of around 7 acres. The particularly appealing flavour of the beer was said to be as a result of the quality of the water. The Anchor Brewery drew its water from a deep well under the premises.

Sadly, none of these four main Norwich breweries still exist. Various takeovers and mergers in the twentieth century resulted in Watney Mann emerging as the only major brewer in the city. In 1985 it, too, closed, thus bringing to an end a long tradition of large-scale brewing in Norwich.

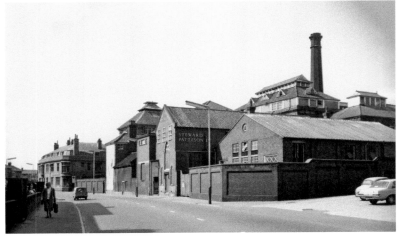

Steward and Patteson Ltd had their brewery in Barrack Street. Four prominent local families were active in the business: the Pattesons, Stewards, Morses and Finches. (Photo by George Plunkett)

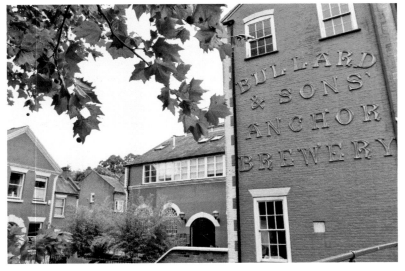

Many of the Anchor Brewery buildings of Bullard & Sons survive, albeit as residential accommodation. (Photo by Tony Scheuregger)

Lacons Brewery, although based in Great Yarmouth, had a firm foothold in Norwich. Lacons' emblem, a falcon, can still be spotted in the city. (Photo by Tony Scheuregger)

PUBS AND INNS

Present-day visitors to Norwich are often told that there used to be one pub for every day in the year. This was certainly true in the early 1800s. However, by the end of the nineteenth century this had risen to well over 600 licensed premises, including beer and refreshment houses, although today probably only a couple of hundred remain. The Adam and Eve in Bishopsgate, close to the cathedral, is widely acknowledged to be the oldest pub in the city still serving ales. Earliest references date back to 1249 when it was used as a brewhouse for the monks at the nearby Great Hospital. Another of Norwich's drinking establishments had a similarly interesting clerical past. The former Dolphin Inn in Heigham Street was built during the reign of Elizabeth I and became a bishop's palace until the mid-seventeenth century. Many more of Norwich's pubs and inns dating back centuries have been demolished to make way for new roads and buildings.

Over the centuries, Norwich has been home to around ten Red Lions, nine White Horses, eight King's Arms, seven Royal Oaks, six White Lions, five Cocks, four Duke of Wellingtons, three Half Moons and two Rampant Horses. All these pubs have required signs, some of which have been extremely elaborate. All the Norwich breweries had their own sign-painting departments to produce the artwork for their tied properties. Each pub name was meticulously researched and the signs were hand-painted. Perhaps the most impressive and unique were those created by the eccentric artist John Moray-Smith in the 1930s.

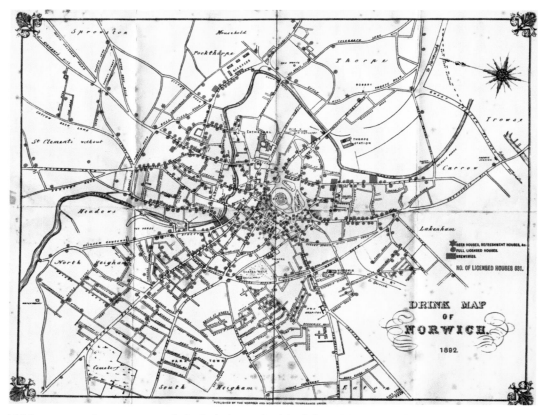

With concern about continued alcohol abuse, the Norfolk and Norwich Gospel Temperance Union issued a drink map of Norwich in 1892, detailing all the pubs, inns, taverns and breweries.

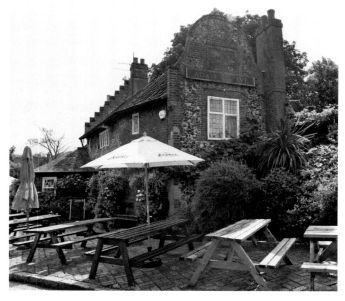

The present Adam & Eve building has Dutch architectural influences. The original building, long since disappeared, was frequented by workmen building the cathedral. (Photo by Tony Scheuregger)

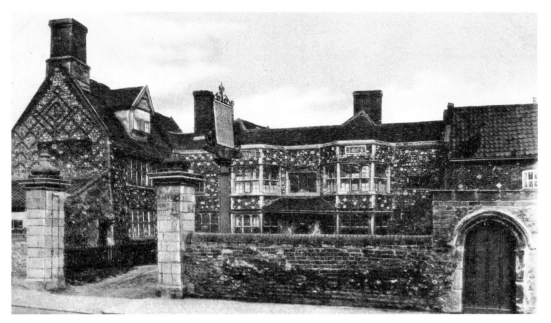

One of the more unusual inns in Norwich was the Dolphin. Before it served customers and thirsty travellers ale, it had been a bishop's residence.

The Tiger in Fishergate was run by John Adcock, a worsted weaver, in the eighteenth century. It was demolished in the late 1930s, a few years after this photograph was taken. (Photo by George Plunkett)

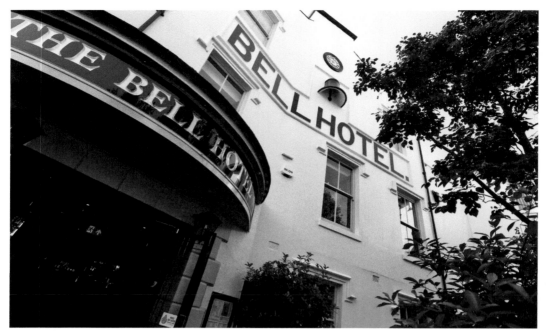

There were six pubs and inns in Norwich called The Bell over the centuries. This one is believed to date from 1480 and is still in business today. (Photo by Tony Scheuregger)

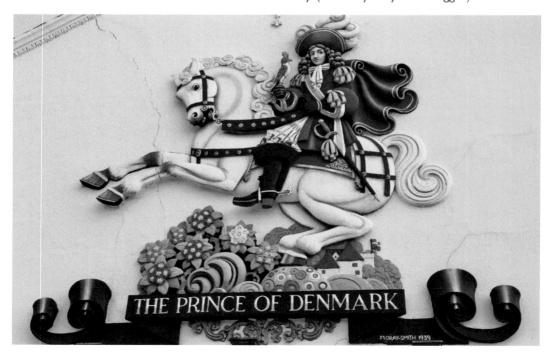

In 1939, John Moray-Smith produced this splendid sign that still adorns the side of the Prince of Denmark pub on Sprowston Road. (Photo by Tony Scheuregger)

COLMAN'S

The names of Colman's and Norwich are synonymous to most people across the country. It is therefore sad that the last jar of the firm's iconic mustard rolled off the production line in July 2019 to be followed shortly afterwards by its employees. J. & J. Colman started life as a milling firm in the nearby village of Stoke Holy Cross. There Jeremiah Colman took over a fledgling mustard business in 1814, improving the quality of production and machinery. In the late 1850s, Colman moved his business to a site in Carrow, Norwich, which was convenient for both river and rail transportation. It received a royal warrant in 1866 to supply mustard to Queen Victoria. The firm grew rapidly and by 1900 it had around 2,500 employees. The family business became known for the welfare they offered to their workers. A school was set up for children of employees and the company employed a staff nurse. After taking over rival mustard-maker Keen Robinson & Co. in 1903, Colman's also made their name by inventing Robinson's Barley Water, used originally to refresh and hydrate tennis players at the Wimbledon Championships. Although Colman's mustard production continues, it is now made by the multinational corporation, Unilever.

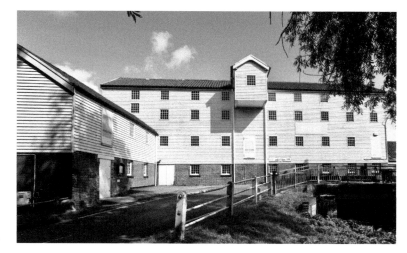

The birthplace of Colman's mustard in Stoke Holy Cross. (Photo by Tony Scheuregger)

Colman's Carrow Works had access to the River Wensum, allowing easy loading and unloading of wherries.

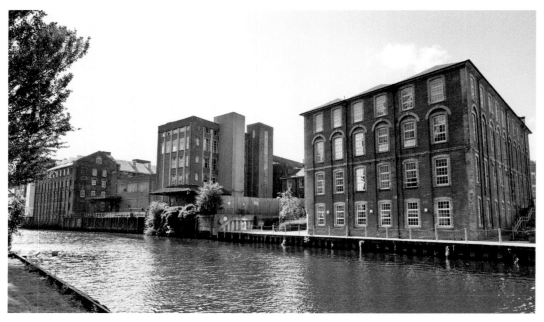

Many of Colman's buildings still line the river. (Photo by Tony Scheuregger)

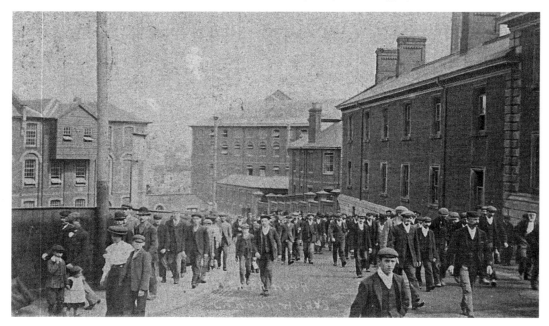

Some of the thousands of Colman's employees at the end of the working day at the Carrow Works in the early twentieth century.

Colman's advertising posters
appealed to old and young alike.

JARROLD

The family firm of Jarrold has played a part in the lives of generations of Norwich families for almost two centuries, since John Jarrold opened a bookselling and printing business in the city in 1823. He ran the firm with his four sons in Cockey Street, later renamed London Street, opposite its present-day successor. As his business empire grew, he gradually acquired more of the current Jarrold site. Publishing became a successful arm of the business and the first edition of one of the most famous children's books ever, Anna Sewell's *Black Beauty*, was published by Jarrold in 1878. By the early twentieth century, Jarrold had developed into a substantial retail business, opening branches in Cromer, Great Yarmouth, Sheringham and Lowestoft. In need of more space, its printing arm moved to St James' Mill. This move coincided with the redesign by the original architect, George Skipper, of Jarrold's flagship store. Later, in 1923, he remodelled the frontage of the store in local terracotta, which, by now, was selling a wide range of household goods. Today, its most familiar business is the landmark department store in the centre of Norwich but the company's other major interests in the city include the office and residential development St James Place, and Jarrold Training, which provides business training from its headquarters in St James' Mill.

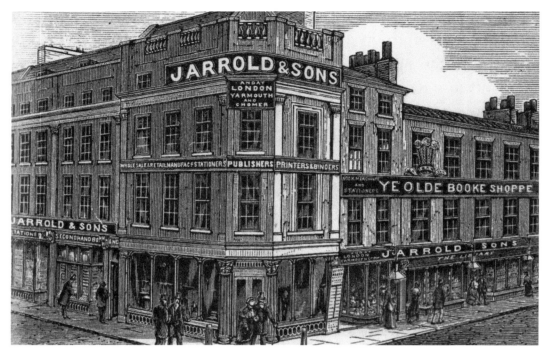

Jarrold & Sons' original store on the corner of London Street and Exchange Street in 1890.

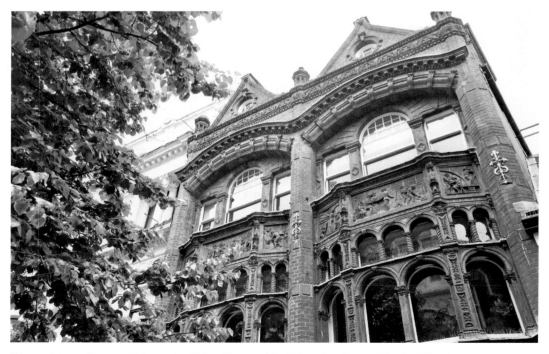

The architect George Skipper had his offices at No. 7 London Street. The building is now part of Jarrold's department store. (Photo by Tony Scheuregger)

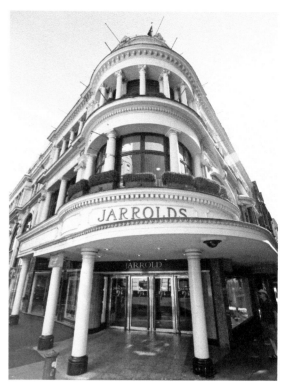

The main frontage of Jarrold's department store was redesigned twice by George Skipper. (Photo by Tony Scheuregger)

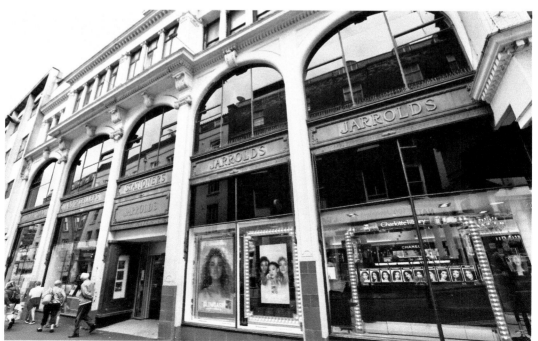

Much of the exterior of Jarrold's reflects the art deco style of the age. (Photo by Tony Scheuregger)

CALEY'S

A. J. Caley & Sons began life as a chemist in London Street in 1860. Three years later they started to make mineral water and other carbonated drinks, and such was the success of this venture, they moved to premises in Chapelfield Road in 1883. Because of the seasonal nature of the soft drinks trade, Caley's started to produce drinking chocolate, followed by eating chocolate. A larger factory was constructed and by the end of the nineteenth century, the firm was employing around 700 people and exporting their products all over the world. In 1898, Caley's jumped on the Christmas cracker production bandwagon, which proved a highly profitable business. In the twentieth century, the firm continued to grow and in 1932 it was acquired by Mackintosh, later Rowntree Mackintosh, and then in turn by Nestlé, although the Caley's brand continued to be produced in Norwich and sold under the Caley's brand name until the 1960s. The Norwich factory was closed in 1994 and demolished ten years later, making way for the Chapelfield shopping centre.

Caley's factory at Chapelfield was destroyed by bombing in the Second World War and had to be completely rebuilt. (Photo by George Plunkett)

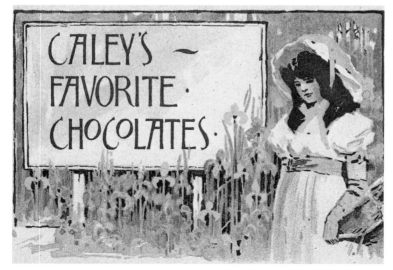

Caley's chocolates remained the mainstay of their operation. In the 1920s, they were known for their Easter eggs.

Nothing remains of Caley's large factory. (Photo by Tony Scheuregger)

HILLS & UNDERWOOD

Today there is no trace of the once largest firm of its kind in the country. The Norwich Vinegar Works and Gin Distillery occupied a vast site in Prince of Wales Road and Recorder Road, which included a long river frontage. It was constructed by Hills & Underwood in 1865 and covered 125,000 square feet of offices, fermenting rooms, vat stores, gin stills, spirit stores, boilers and warehouses. They even made their own barrels in which to store their products. The firm is thought to have had its origins a century earlier when there were several vinegar yards operating in the city. Hills & Underwood sold many different vinegars, including brown, pale, straw coloured and distilled white. Vinegar was touted as having many everyday uses including taking a teaspoonful to cure hiccoughs! In 1911, the firm was bought out by Sir Robert Burnett & Co. of London and the works closed. The last of the buildings was demolished in the 1960s.

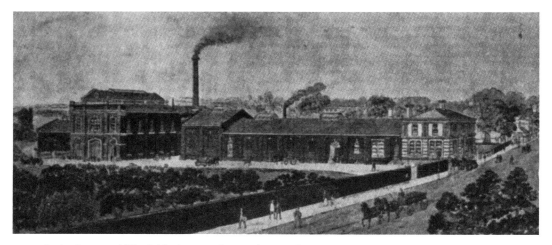

At its factory, Hills & Underwood manufactured vinegar in much the same way as beer. Their large vats stretched in long lines almost touching the roof of the large storage building.

HILLS & UNDERWOOD'S

PURE MALT

VINEGAR

PURITY & STRENGTH GUARANTEED.

(SEE ANALYSIS FROM MOST EMINENT MEN OF THE DAY.)

CELEBRATED

OLD TOM GIN

DISTILLERY AND VINEGAR WORKS,

NORWICH,

25, EASTCHEAP, &

1, 2, 29, 30. 31, & 32, ST. MARY-AT-HILL,

LONDON.

WINES AND SPIRITS IN WOOD
AND IN BOTTLE.

LIQUEURS.

Hills & Underwood sold brown, pale, sherry straw coloured or distilled (white) vinegar. The firm also exported their gin.

READ'S

The name R. J. Read Ltd is still well known among Norwich residents because, until the late twentieth century, the milling firm was one of the last firms to use traditional wherries to transport their goods along the river in the centre of the city. However, the name of their premises in King Street, City Flour Mills (the former Albion Mill), lives on, albeit as the title of a modern development of swanky riverside apartments. Robert John Read moved from Suffolk to Norwich in 1889 and set up a flour mill with then state-of-the-art technology. This was roller milling where fine white flour was able to be produced in great quantities using steam and then electric power. He began production of self-raising flour in 1906 and expanded into a former yarn mill with a large river frontage and wharves large enough to handle seagoing vessels.

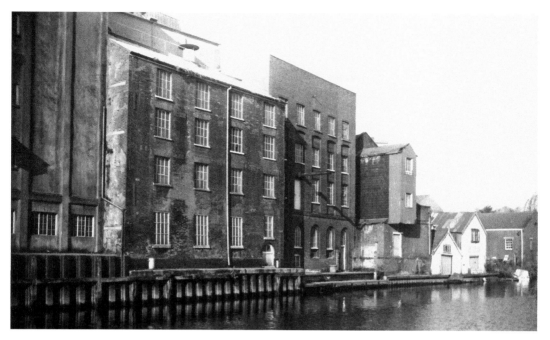

Read's flour mills, between King Street and the river, were still very much industrial buildings in 1990. (Photo by George Plunkett)

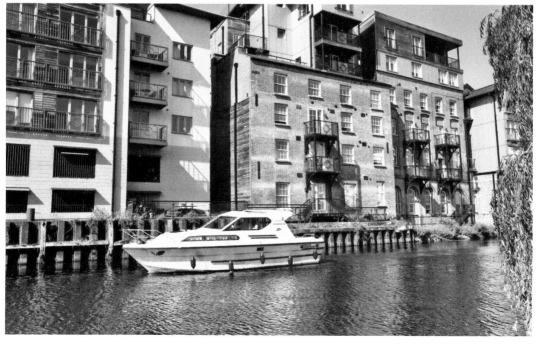

Today, residents of swanky apartments live where Read's used to mill their flour. (Photo by Tony Scheuregger)

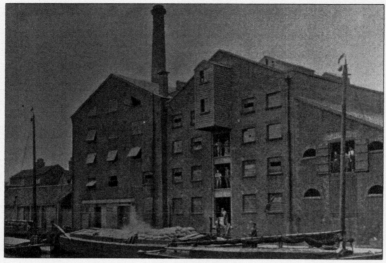

An advertisement from 1910 shows Read's employees loading bags of flour onto wherries.

BARNARDS

In the late Victorian period, Norwich started to become a major centre for engineering. Charles Barnard was therefore an early local pioneer when he established his ironmonger's business in the marketplace in 1826. In 1844, he built the first patented wire-netting machine, which sold worldwide. Soon after that he joined forces with his sons and with a Cornish engineer to form Barnard, Bishop & Barnard. The expanding business moved into spacious premises elsewhere in the city. Although Charles Barnard died in 1871, the firm went from strength to strength, designing and building all manner of ironwork, and later steel, structures ranging from garden chairs, bridges, railway buildings and even steam engines. Perhaps their best-known construction is the Norwich Gates that form the entrance to Sandringham House, given to the Prince and Princess of Wales in 1863 as a wedding present by the citizens of Norwich and Norfolk. A Norwich landmark made by Barnards but long-since disappeared was a wrought- and cast-iron pavilion or pagoda in Chapelfield Gardens.

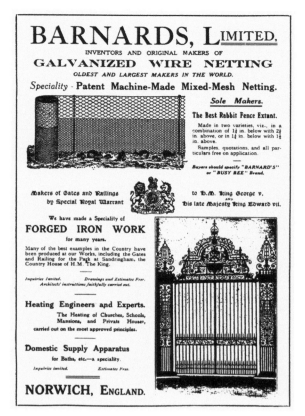

An advertisement from 1911 depicts Barnards' Sandringham Gates and proudly announces that the company are makers of gates and railings by special royal warrant.

Barnards' pavilion or pagoda was installed in Chapelfield Gardens in 1880. When it became unsafe through rust and neglect it was dismantled in 1949.

A POTPOURRI OF OTHER SHOPS AND BUSINESSES

From 1815 through to the 1950s, the impressive frontage of Chamberlin's department store dominated the market area in Norwich. It was founded by a Scot, Henry Chamberlin, and offered a first-class shopping experience for those wanting to buy homewares and clothes. It also boasted a refreshment room for its customers. A description of the store, written at the end of the nineteenth century, reads 'for elegance, comfort and completeness, they stand unrivalled by any similar establishment in the country'.

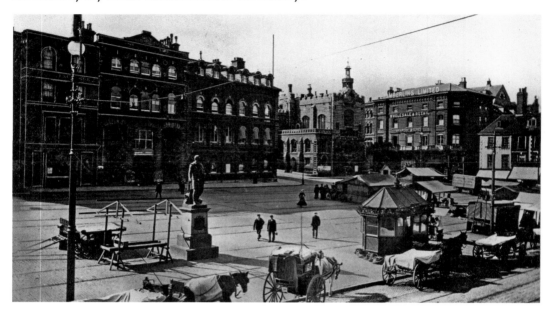

Chamberlin's department store occupied a prominent position in the marketplace, here depicted to the right of the Guildhall in an Edwardian postcard.

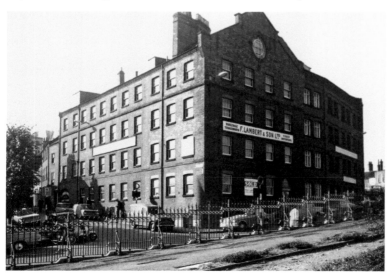

Lambert's tea and tobacco warehouse once stood in the Haymarket. An early twentieth-century advertising sign declared that 'Lamberts teas are the best'! (Photo by George Plunkett)

Crystal House was damaged by wartime bombing but was later repaired. Recent uses have been as a furniture warehouse and as a toy and model shop. (Photo by Tony Scheuregger)

The Victorian industrial age is reflected in some of the surviving commercial buildings in Norwich, and no more so than the Crystal House in Cattle Market Street. It was built in 1862 and was inspired by its namesake, the Crystal Palace in London, which was constructed to house the Great Exhibition. The Crystal House was built for Holmes & Sons, a firm of machine engineers, who stayed in the building until the company ceased trading in 1905. The unusual front of the building uses metal columns and metal-framed windows, allowing natural light to flood in.

Bonds of Norwich started life in 1879 as a small drapery store in Ber Street. From these small beginnings, the owner, Robert Herne Bond, built a competition-beating family business. In 1914, an arcade was built linking his now two shop frontages on Ber Street and All Saints Green and, after his death, Bonds was run by Robert's sons and grandsons. Further extensions in All Saints Green were added, although almost the entire store was burnt down in the German bombing raids of the Second World War. The store front we see today was designed by Robert Owen Bond and completed in 1951. The shop remained as Bonds until 2001 when it was rebranded as John Lewis.

One of Norwich's Victorian architects was responsible for transforming the city centre shopping experience more than any other. He was George Skipper, who, as well as designing some of Norwich's most notable commercial buildings, was responsible for the art nouveau covered shopping walkway called the Royal Arcade. It opened in May 1899 and the richly decorated, glazed tiles on the interior and exterior walls, together with the elegant lines of the structure, caused a local newspaper to comment, 'It is as if a fragment of the Arabian nights has been dropped into the heart of the old city'. One shop still open in the arcade today, the toy shop Langley's, has been there since the very beginning.

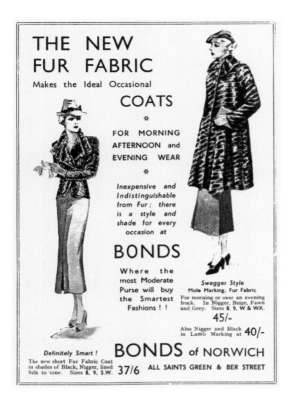

Bonds of Norwich prided themselves on quality at affordable prices.

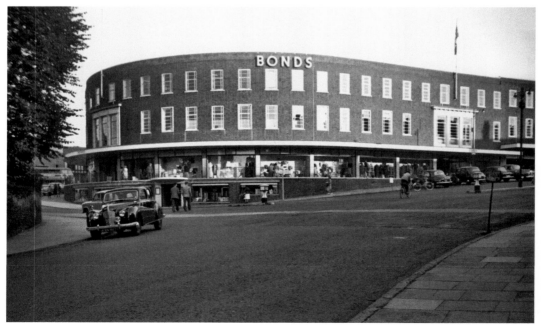

The new Bonds department store building in 1955, which is still a familiar landmark in central Norwich. (Photo by George Plunkett)

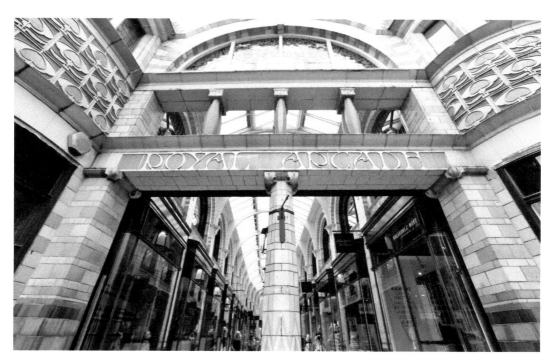

The lettering over the entrance doorway to the Royal Arcade is pure art deco. (Photo by Tony Scheuregger)

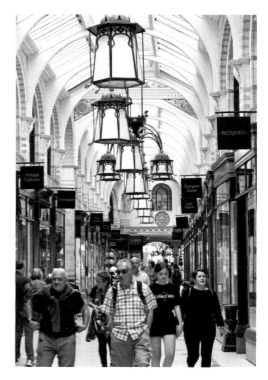

The Royal Arcade still attracts the finest retail establishments. (Photo by Tony Scheuregger)

TWENTIETH-CENTURY NORWICH

The twentieth century in England saw more changes than, perhaps, in the previous 900 years and Norwich was no exception. In 1912, the city hit the national headlines when, after three days of heavy rain, the centre and suburbs suffered extensive flooding. Over 3,500 homes were damaged, as well as many businesses. The railway and other public services were suspended. This was not, of course, the only disaster to hit Norwich. The First World War hit in the form of over 3,500 local lives lost on the battlefield and many more family members left to mourn. Factories and businesses adjusted to wartime by employing women to continue their output.

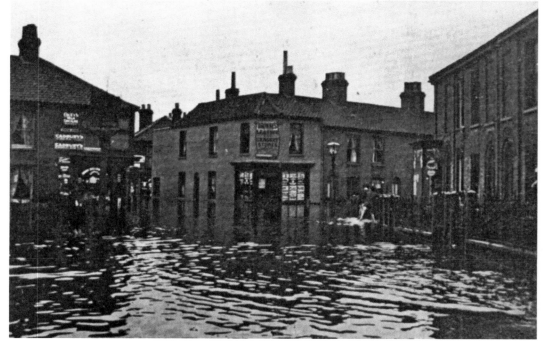

Mancroft Street, like many other city centre areas, was inundated in 1912.

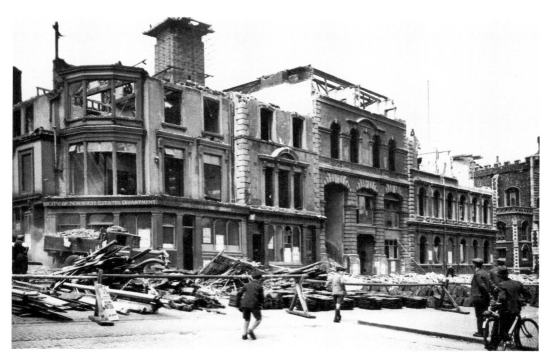

On 14 May 1938, demolition of buildings in the centre of the market area was underway, to be replaced by the new City Hall. (Photo by George Plunkett)

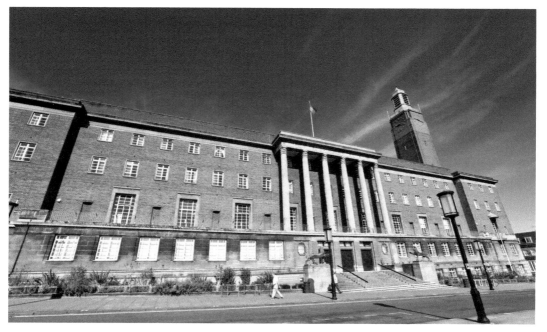

A competition was held to design the new City Hall, attracting 143 entries. The new building was officially opened by George VI. (Photo by Tony Scheuregger)

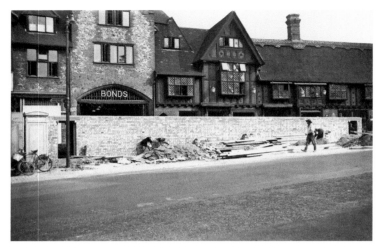

In 1939, air-raid precautions were already in place. This temporary wall was constructed in front of the old Bonds shop on All Saints Green. (Photo by George Plunkett)

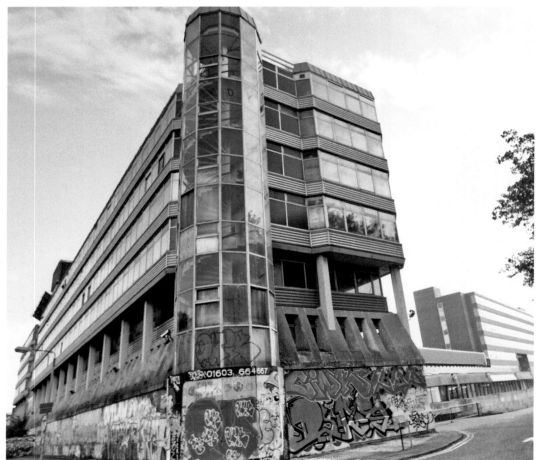

Sovereign House was a bold symbol of 1960s architecture and was home to Her Majesty's Stationery Office. (Photo by Tony Scheuregger)

In his *English Journey* of 1934, author and social commentator J. B. Priestley wrote of the city, 'It is no mere jumped-up conglomeration of factories, warehouses and dormitories … Norwich is really a capital, the capital of East Anglia'. One of the most drastic changes to Norwich city centre in the period between the two wars was the 1938 redevelopment of the market area. The city's administrative buildings were now too small, and the market needed some kind of uniformity in the design of the stalls. So, a swathe of older buildings was demolished to make way for a new City Hall and a new market layout was constructed.

Before and after the outbreak of the Second World War, Norwich residents prepared for air raids; by 1942 there was enough room in air-raid shelters for everyone in the city. The first raid was on 9 July 1940, but the most serious raids were the so-called Baedeker raids on the nights of 27 and 29 April 1942. Shops, factories and houses across the city suffered extensive damage. The Caley's chocolate factory, Bonds department store and the Hippodrome theatre were all casualties of this sustained bombing. Such widespread destruction led to a programme of post-war rebuilding. This redevelopment and expansion of the centre of Norwich continued through to the end of the century, with many new office blocks appearing in the cityscape.

THE FOOTWEAR INDUSTRY

In the first half of the twentieth century, a new industry dominated the economic life of Norwich. The textile trade had all but disappeared and had been replaced by shoe and boot making. The city's footwear industry had steadily grown during the 1800s and by the turn of the century there were over 7,500 people employed in this trade. It probably reached its peak in the 1930s when there were nearly 11,000 employees involved in the manufacture of boots and shoes in Norwich. There were several firms that were major producers with national reputations, such as Haldensteins, Sextons and Norvic. This level was sustained through until the 1970s when the city was ranked fourth as a footwear manufacturer, making nearly 11 million pairs each year. It specialised in ladies' fashion shoes and children's footwear.

Shoes had, of course, been made in Norwich since earliest times with individual, self-employed shoemakers fashioning made-to-measure shoes for their clients. Although more large-scale footwear manufacturing had started elsewhere in the country much earlier, it was not until 1792 that James Smith established a shop and factory in the city centre providing ready-made shoes. His new venture proved a huge success and his business was passed down the generations, gaining a reputation for high-quality shoes. By the early twentieth century, a larger factory was needed, where they could install the latest machinery, as well as providing good working conditions for their workers. So, in 1907 the firm moved to a newly constructed factory, offices and warehouse complex in Crome Road. It was after the First World War that Smith's original firm adopted the trademark 'Start-rite' and began their specialism of children's fitted footwear. In 1943, they carried out the first ever nationwide survey of children's feet and their findings transformed the way children's shoes were designed and fitted. Today, Start-rite is still one of the famous brands of children's footwear, although in 2003 the company ceased production in this country, outsourcing its operations overseas.

James Smith's success in mass-producing shoes in Norwich soon caught on and other companies appeared on the scene. However, many still operated on the basis of using outworkers for the separate processes involved in shoe production such as cutting out the uppers and soles, a process known as clicking and pressing, and finishing, where the final shoe was trimmed and tidied up. Over time, more of these processes were undertaken in the factory. Such was the scale of the Norwich footwear industry that between the 1920s and 1975 shoemakers were trained in a central workshop and small-scale factory.

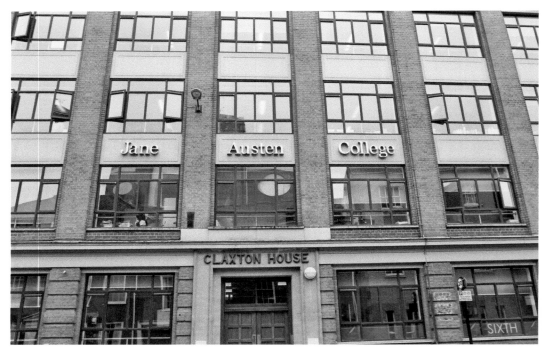

Now put to very different use, the old Norvic Shoe Company Ltd – formerly Howlett & White – factory premises. (Photo by Tony Scheuregger)

Before their merger with Bally, Haldensteins specialised in high-quality footwear for women and children. They made the wedding shoes for Princess Mary, daughter of George V. (Photo by Tony Scheuregger)

The only surviving remnant of the Start-rite factory building – now incorporated into an apartment block – bears James Smith's initials and the date of founding of his company. (Photo by Tony Scheuregger)

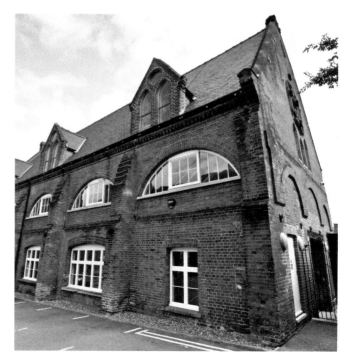

Shoemakers were trained at what was then the Norwich City College and Art School, now Norwich University of the Arts. (Photo by Tony Scheuregger)

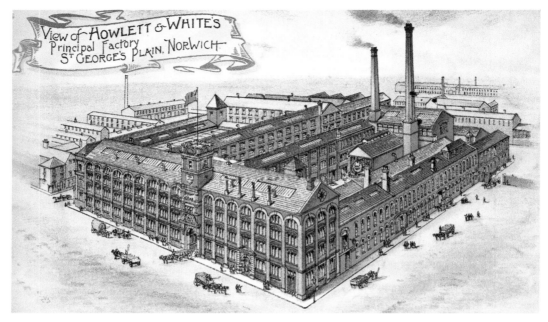

On the cover of their fiftieth anniversary booklet in 1896, Howlett & White show off the extent of their works on St George's Plain. (Photo by Tony Scheuregger)

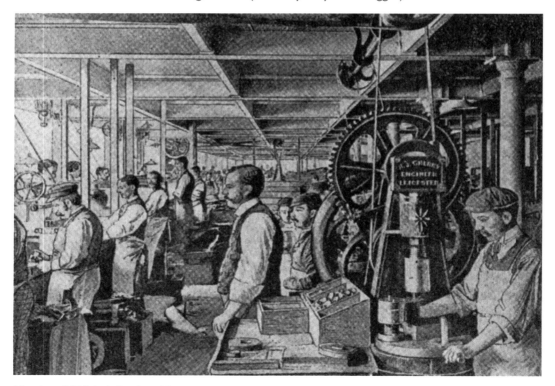

Howlett & White's heel-making room.

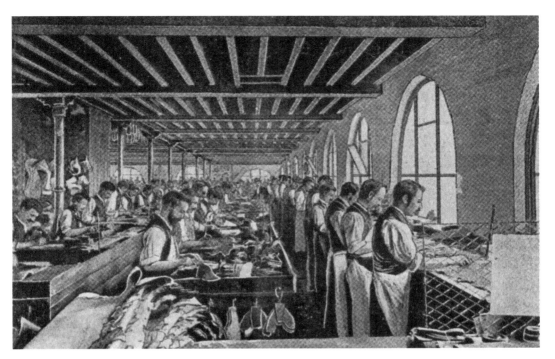

Howlett & White's clicking room.

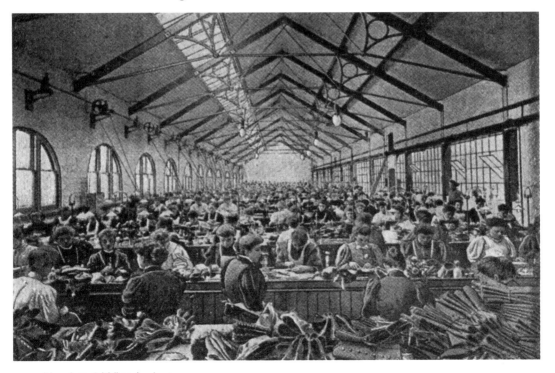

Howlett & White's closing room.

Sexton's moved to St Mary's Works after a fire destroyed their factory at St Edmund's Mills in January 1913. (Photo by Tony Scheuregger)

The Co-operative Wholesale Society Ltd occupied premises in Mountergate bought from the engineering firm Boulton & Paul. Although the Co-operative Group manufactured other goods, their Norwich factory concentrated on footwear. (Photo by Tony Scheuregger)

While some of Norwich's former shoe factories no longer exist, some are now used for very different purposes. The free school, Jane Austen College, is the current occupier of the former factory of Howlett & White. This shoemaking enterprise was to become world famous, later called the Norvic Shoe Company. At the beginning of the twentieth century, Howlett & White was one of five companies dominating the shoe industry and their factory at St George's Plain grew to employ almost 2,000 people, producing 25,000 pairs of shoes a week. During the two world wars, the firm provided boots and shoes to Britain's armed services.

St Mary's Works, built in the 1920s, was formerly the site of another great footwear manufacturer: Sexton, Son & Everard. Many Norwich shoe manufacturers were hit by a slump in the entire industry after the First World War, but whereas over twenty Norwich firms were forced to close, others thrived, including Sexton's. The company marketed itself as manufacturers of ladies' medium- and high-grade footwear. They also specialised in dancing shoes for men, women and children. In 1972, the firm went into receivership with the loss of 700 jobs.

Today, there are no footwear factories left in Norwich. However, the small family firm of Bowhill & Elliott, established in 1874, still handcrafts bespoke shoes on their original premises in London Street.

SHOPPING

The Norwich markets continued to be a draw for residents and people from the surrounding countryside. As well as the main market, there was the cattle market, which, from the mid-eighteenth century through to 1960, was located in an area just below the castle mound. This livestock market catered for not only cattle but also sheep, pigs, calves and poultry. Until well into the twentieth century, the animals were driven through the streets to and from the market. In 1993, the Castle Mall shopping arcade was built on the site of the former cattle market, although most of the mall is hidden underground. A second shopping complex followed twelve years later, constructed on the site previously occupied by the Caley's chocolate factory in Chapelfield. When it opened, it claimed to be the largest of its kind with eighty shops and seventeen cafés and restaurants.

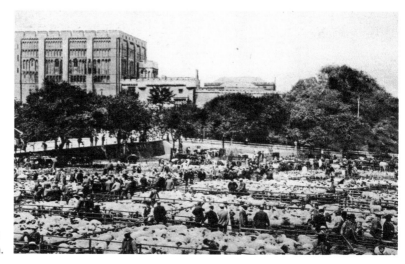

Sheep for sale in the cattle market, after having been driven through the streets of Norwich.

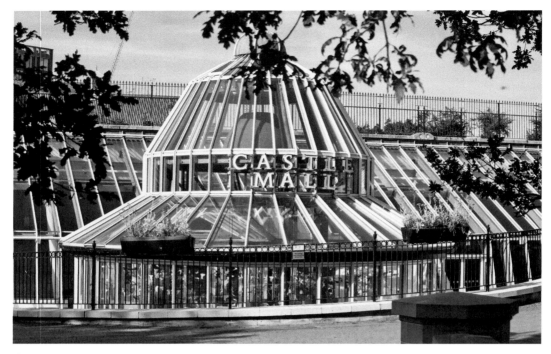

Castle Mall occupies the site where once cattle, sheep, pigs, calves and poultry were bought and sold. (Photo by Tony Scheuregger)

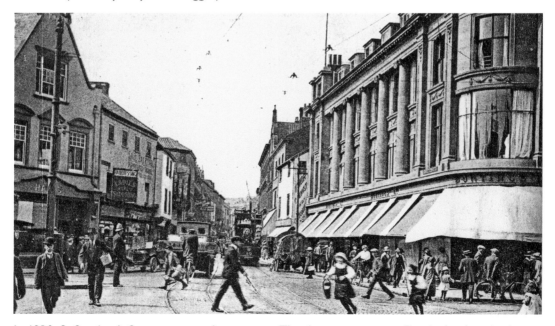

In 1920, St Stephen's Street was much narrower. The department store Bunting's advertised itself as 'draper, outfitter, boot and shoe specialist, silk mercer, carpet and Manchester warehousemen'.

Depicted in the 1910s, London Street was one of the main shopping thoroughfares.

Davey Place has, arguably, changed very little in the past century.

Many of Norwich's department stores of the twentieth century have now disappeared, including Curl's, Garlands and Bunting's. Although St Stephen's Street has changed out of all recognition in the past century, it is still a main shopping thoroughfare. Several smaller shops, many established in the nineteenth century, still inhabit the streets leading to the marketplace, including London Street and Davey Place.

ENGINEERING

In the twentieth century, two large firms dominated the manufacturing sector in Norwich. Both flourished, to a large extent, as a result of the two world wars. The first of these had its origins in an ironmonger's shop in London Street, then called Cockey Lane, in 1797. From these small beginnings grew the firm of Boulton & Paul. In the 1860s, the company had opened a small factory in Rose Lane, which, over the next century, was expanded. They produced a wide range of goods from wire netting, kitchen ranges to mincing and sausage-making machinery. As well as ironmongery, they also manufactured products from wood, including prefabricated huts and churches. In 1910, Boulton & Paul built the sledges used by Captain Robert Falcon Scott on his ill-fated expedition to the Antarctic.

The First World War, which had begun with cancellation of orders, proved highly profitable for Boulton & Paul. In 1915, they were asked to make aeroplanes and so, during the war, the

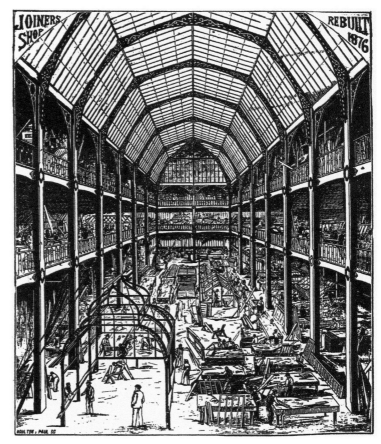

This illustration of the greenhouse building department at the Rose Lane works of Boulton & Paul shows the scale of their operation.

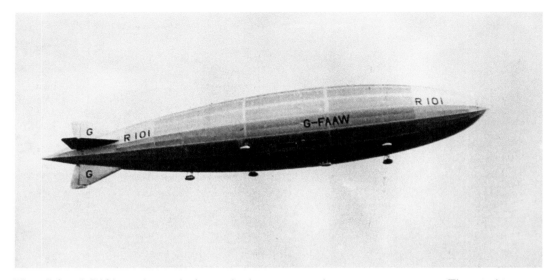

The ill-fated R101 airship, which crashed on its maiden overseas voyage. The airship comprised over 11 miles of girders manufactured by Boulton & Paul.

Boulton & Paul's massive Riverside Works is long gone. All we have to remind us of this pioneering company is two engraved steel girders near the Novi Sad Bridge. (Photo by Tony Scheuregger)

company produced 1,550 Sopwith Camels along with other models of aircraft. In total they made 2,530 military planes and supplied over 5,000 miles of the wire used to defend the British trenches. At the end of the war, Boulton & Paul continued to make light metal aircraft for the Royal Air Force, as well as flying boat hulls for the navy. It was also in the 1920s that the firm made all the component parts – steel tubing, cables, nuts and bolts – of the R101 airship. In the Second World War, fighter planes were manufactured, and the company also diversified into other sectors. It finally ceased trading in 1991.

Unlike Boulton & Paul, Laurence Scott is still an important name in the manufacturing industry to this day. It also maintains its Norwich works in Hardy Road. Laurence Scott's operations were established in 1883 with William Harding Scott's dynamo, built to be used by local mustard and starch manufacturers. The firm's Gothic Works in Hardy Road were established in 1896, specialising in the design and manufacture of electrical generators and motors. The company went on to provide motors and winches for many of the most important ships of the early twentieth century, including the *Titanic* and ocean-going liners such as the *Queen Mary* and *Queen Elizabeth*. During the First World War, Laurence Scott moved into mass production of gun shells. In more recent times, it has produced electric propulsion motors for nuclear submarines and the tunnelling machine used to dig the British side of the Channel Tunnel.

Laurence & Scott's Gothic Works had 7,500 square metres of workspace and by 1937 there were over 3,000 employees. (Photo by George Plunkett)

MONEY

The second half of the twentieth century saw the rise of a wide range of service industries, as well as manufacturing firms in Norwich. These took the place of the footwear and engineering trades. By far the largest and most high profile of all Norwich companies in the financial sector today is Aviva. It is one of the county's biggest employers, with 5,200 staff in Norwich. In 1905, the then Norwich Union Life Society opened its new head office in Surrey Street. Designed by the local architect George Skipper, it was intended to impress, with an entrance hall that was finished in marble. Following various mergers, by 1961, the total assets of the Norwich Union Assurance group were over £250 million. Several office blocks in the centre of Norwich housed its vast staff.

The general banking sector in Norwich declined in the latter part of the twentieth century. The city's Barclay's Bank branch was, in 1961, one of the largest in England. This bank, along with others, have significantly downsized with the advent of new ways of banking. However, Norwich continued to attract other general insurance firms and is now home to over fifty corporate headquarters in the sector, including the insurance broking and risk management solutions firm Marsh UK. Norwich is one of Britain's fifteen financial centres of excellence.

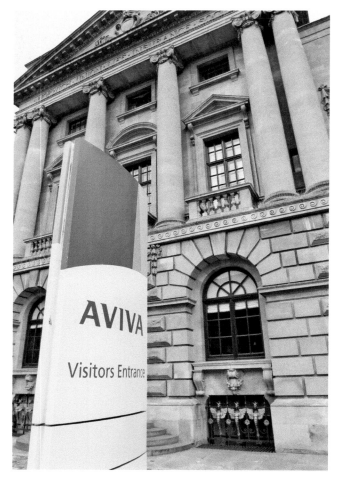

Aviva still occupies the impressive Surrey Street building. (Photo by Tony Scheuregger)

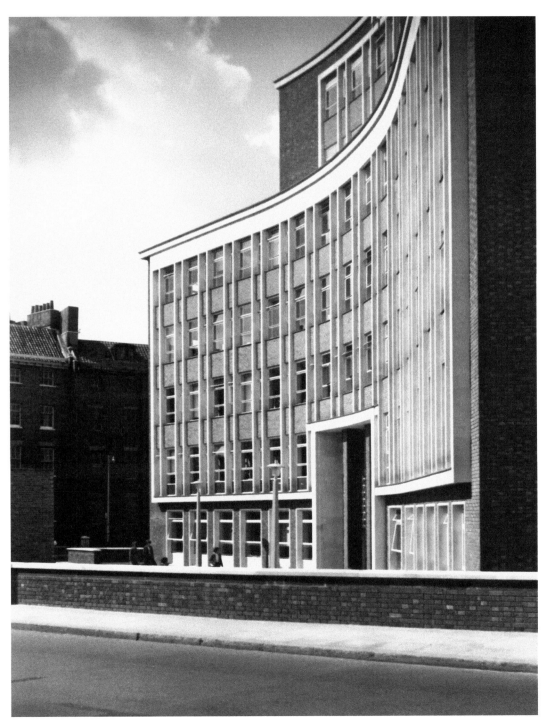

Norwich Union occupied several buildings in the city, including this 1960s office block in All Saints Green. (Photo by George Plunkett)

Norwich Union offered a wide range of insurance policies.

Even in the 1940s, bicycle theft was a problem.

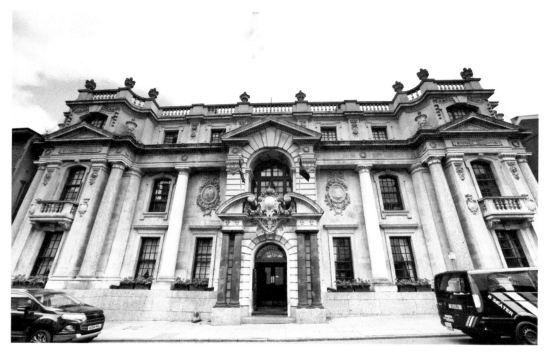

Another of architect George Skipper's buildings was originally the Norfolk and London Accident Assurance Offices, built in 1906.

MEDIA

The eighteenth century had witnessed the introduction of regional newspapers in the country; in fact, in 1701 the *Norwich Post* became England's first provincial newspaper. In Norfolk, other prominent early rags were the *Norwich Mercury*, *Norfolk Chronicle* and the *Norfolk News*. Then, in 1870, the *Eastern Daily Press* was launched. In the following 130 years, mergers and acquisitions of various regional news organisations resulted in the large media company Archant, which has its headquarters in Norwich. Today, Archant produces over 140 newspapers and lifestyle magazines covering the whole of the country, publishing 1 million copies a week in print with their associated website reaching an audience of over 6.4 million readers a month.

Although Anglia Television was not one of the first Independent Television Authority stations to go on air, the name has proved one of the most enduring for several generations of viewers. It launched in 1959 to serve the east of England using as its studios the former Agricultural Hall in Norwich. The company, with its memorable 'logo' of a silver knight on horseback, produced nationally known programmes such as *Sale of the Century*, *Tales of the Unexpected* and *Survival*. At its height it occupied both the Agricultural Hall and the neighbouring former Crown Bank/Post Office. Today, it operates as ITV Anglia, broadcasting primarily news to the eastern counties.

THE EASTERN COUNTIES
DAILY PRESS

SATURDAY, OCTOBER 29th, 1870.

A FARMER CHARGED WITH PERJURY.

NORWICH QUARTER SESSIONS.

THE HEALTH OF MR. BRIGHT.

REPRESENTATION OF COLCHESTER.

EAST ANGLIAN OPINION.

MORE NEWS FROM METZ:

173,000 Prisoners, and 6,000 Officers Taken.

NAPOLEON GOING TO ELBA.

REPORTED FRENCH VICTORY:

1,200 PRISONERS TAKEN.

PRICE ONE PENNY.

A handbill for the first issue of the *Eastern Daily Press*. Although a provincial newspaper, the headline news mostly covered stories of national importance.

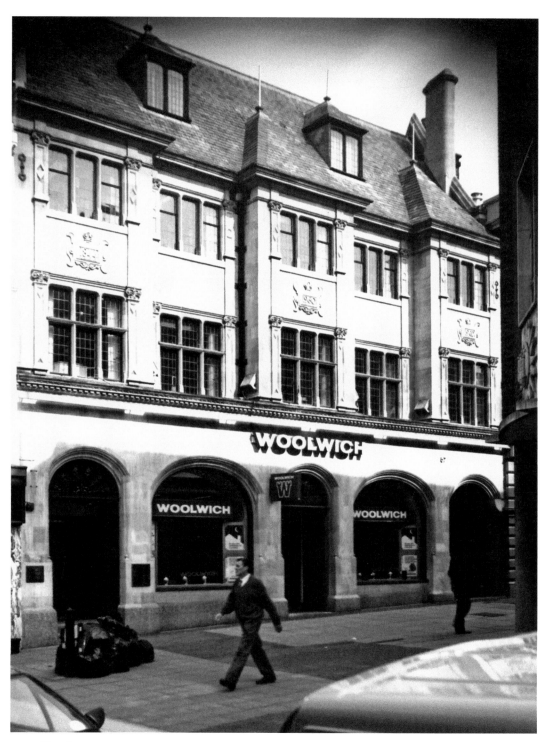

The *Eastern Daily Press* had their offices in London Street. (Photo by George Plunkett)

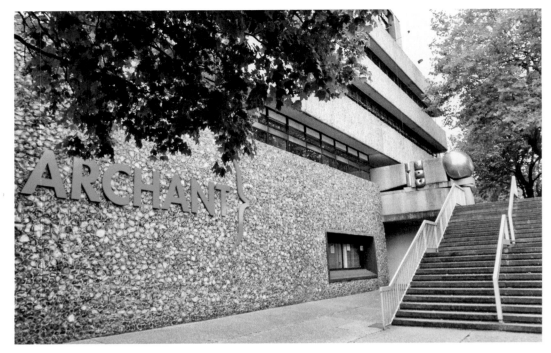

Archant can trace its roots back to 1845, with the founding of the weekly *Norfolk News* by four free-thinking Norfolk businessmen. (Photo by Tony Scheuregger)

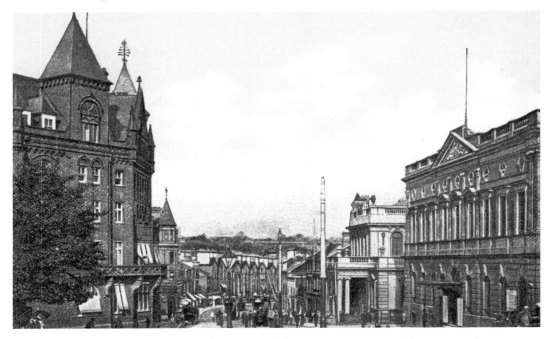

This postcard looking down Prince of Wales Road, dating from the turn of the century, depicts the Agricultural Hall on the extreme right, later to house Anglia Television.

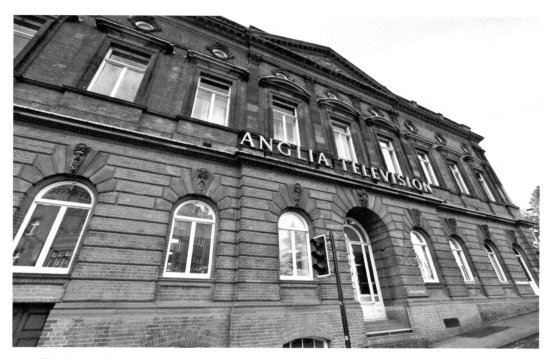

The Anglia Television sign still adorns the front of the building, now home to the renamed ITV Anglia. (Photo by Tony Scheuregger)

Anglia Television's newer buildings, constructed on the back of the former Agricultural Hall, were named after the Marquess Townshend of Raynham, the company's founding chairman. (Photo by Tony Scheuregger)

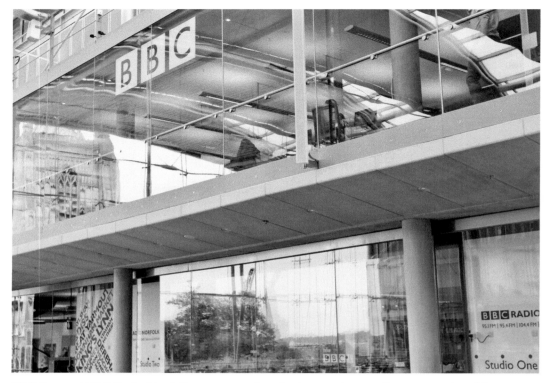

BBC East and BBC Radio Norfolk occupy modern facilities in the new Forum complex. (Photo by Tony Scheuregger)

LEARNING

The new Norwich Central Library was opened by the Queen Mother in June 1963, occupying a central site next to City Hall and St Peter Mancroft. However, just thirty-one years later, an electrical fault led to the building being burnt down with the loss of many books and damage – from water and fire – to many more books and to archives. Like a phoenix rising from the ashes, though, a much larger Millennium Library building has taken its place, which is now a hub of cultural and social activity. It houses not only a multistorey welcoming library but also a tourist information office, cafés, BBC local radio studios and offices, and a large exhibition space. The Norfolk Record Office, with its invaluable collection of archives stretching back many centuries, moved to another purpose-built, state-of-the-art building adjacent to County Hall in Martineau Lane.

The first, small intake of students to the University of East Anglia (UEA) was in 1963 on a site on the outskirts of Norwich. The architect Denys Lasdun was chosen to design the university's core buildings, which included the iconic Ziggurats. His vision was for a campus university with everything a student needed in close proximity. In 1973, Sir Robert and Lady Sainsbury donated their collection of world art to the university. Five years later, the Norman Foster-designed Sainsbury Centre for the Visual Arts opened to house the collection. With a motto of 'do different', the UEA sought to be academically innovative right across the range of subjects it offered.

The spectacular Forum, which has, at its centre, the new Millennium Library. It has topped the charts for several years as the most visited library in the country. (Photo by Tony Scheuregger)

The iconic student accommodation at the University of East Anglia. The university has four faculties and twenty-six schools of study. (Photo by Tony Scheuregger)

The Sainsbury Centre is one of the most prominent university art galleries in Britain, and a major national centre for the study and presentation of art. (Photo by Tony Scheuregger)

NORWICH TODAY

A visitor travelling by road to Norwich today is greeted with a sign declaring it to be 'A Fine City'. Interestingly this is a deliberate misquote from the nineteenth-century Norfolk-born author George Borrow. In his *Lavengro*, he writes 'A fine old city ... Now, who can wonder that the children of that fine old city are proud of her, and offer prayers for her prosperity?' So, this selective quoting of one of the city's former residents is quite deliberate, suggesting that Norwich has changed with the times and is still thriving in the twenty-first century. With a population, in 2011, of over 132,000, the city's largest employment sector is business and financial services, employing around a third of all workers. This is followed closely by the public sector and then by retail, manufacturing and tourism.

In 2006, Norwich was the eighth most prosperous shopping destination in the United Kingdom. As well as the main shopping arcades with the major chain stores, an area of mostly pedestrianised small lanes, alleyways and streets host numerous independent retailers, cafés and restaurants. This 'quarter', known as the Norwich Lanes, was the 2014 national winner in the city category of the Great British High Street Awards. Although many of the large family-run department stores have disappeared, Jarrold still flourishes on a site the shop has occupied for over 150 years. Even more astonishingly, Norwich Market still operates in the same place as it has done for some 950 years. Today, over 200 open-air market stalls open six days a week, making it the largest in England. Its latest revamp, in 2005, provided the permanently covered stalls with modern and hygienic facilities.

In a site between the new Norfolk and Norwich Hospital and the University of East Anglia, the Norwich Research Park has been established. It is home to a wealth of world-class research, providing state-of-the-art facilities for some 3,000 scientists and clinicians working in the areas of food, health and microbial sciences. In total, around 115 businesses comprise this large research community. The John Innes Centre is an international centre of excellence in plant science and microbiology. It incorporates the Sainsbury Laboratory, a world-class centre for investigating plant and crop diseases.

The University of East Anglia, with a current student population of just over 15,000, was ranked twelfth in the Complete University Guide 2018. It is the home of the most prestigious creative writing programme in the country, having been established by Malcolm Bradbury and Angus Wilson in the 1970s. Its graduates include Kazuo Ishiguro and Ian McEwan. In 2012, Norwich became England's first UNESCO City of Literature. It is therefore fitting that Visit

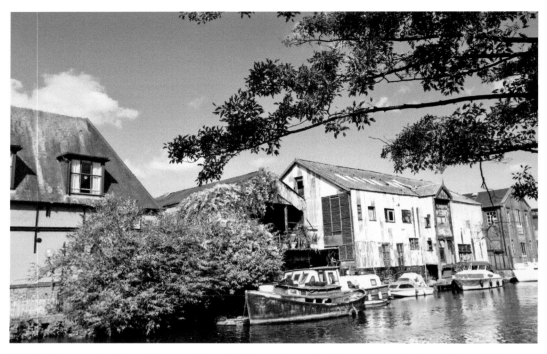

Amid all the new builds and renovation of old factories and mills, some reminders of Norwich's industrial heritage remain untouched. (Photo by Tony Scheuregger)

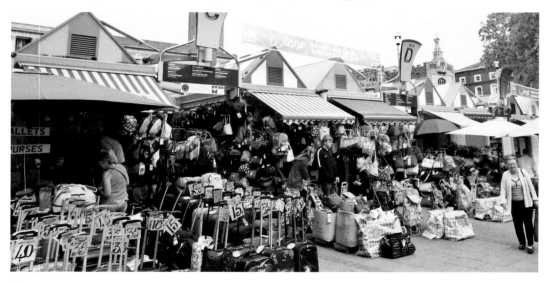

You can buy almost anything you wish in Norwich Market today. (Photo by Tony Scheuregger)

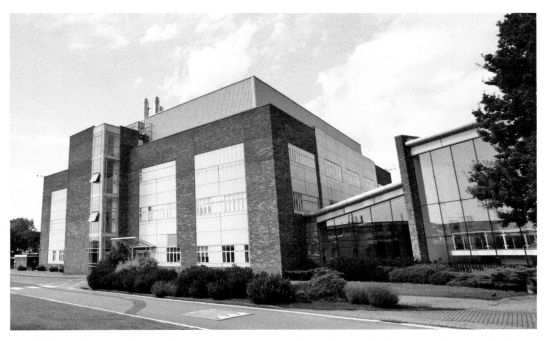

The John Innes Centre is a key stakeholder in the Norwich Research Park, having been instrumental in its establishment. (Photo by Tony Scheuregger)

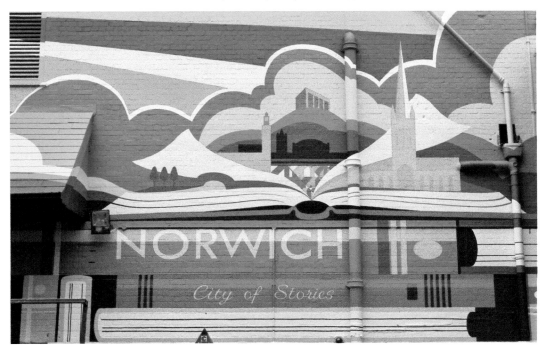

A mural on the side of a building in Pottergate sums up the history of Norwich, the City of Stories. (Photo by Tony Scheuregger)

One of fifty hares dotted around Norwich in the summer of 2018. Captain Jack Rabbit, with St James' Mill as a backdrop, reflects Norfolk's water-based history. (Photo by Tony Scheuregger)

Norwich's heritage through the centuries summed up in the buildings of St Peter Mancroft, City Hall and the Forum. (Photo by Tony Scheuregger)

Norwich, the tourism destination marketing arm of the Norwich Business Improvement District, should choose as their tagline 'The City of Stories'. Visit Norwich not only promotes current local businesses and events, but it also seeks to educate and inform residents and visitors alike about the city's history and heritage. Tourism plays an important part in the economy of Norwich; people of all ages are drawn to the city to visit its many museums and historic buildings. In the past decade, families have flocked to Norwich in the summer months in search of dragons or hares in the form of interactive arts sculpture trails. It is a fun way to celebrate 'A Fine City' in true twenty-first-century style!

ACKNOWLEDGEMENTS

In writing *Norwich at Work*, I have made use of a wide number of books, many by well-respected authors and experts on the city, its history and industries. In particular, *The Story of Norwich* by Frank Meeres has provided an invaluable guide to all aspects of this historic city. I also commend to the reader the various books by Frances and Michael Holmes on different aspects of Norwich's trade and industry. Several of The Norwich Society's publications and online guided walks have also provided me with reputable information.

I am grateful to Tony Scheuregger for taking all the new colour photographs used throughout this book, including on the front cover. As a Norwich resident for many decades, Tony was a good source of help and advice on the changing face of the city. I am also indebted to Jonathan Plunkett for allowing me to use a number of black and white photographs taken by his late father, George Plunkett. Many of these photos are of industrial buildings which no longer exist. I have also made use of several out-of-copyright postcards, as well as other old illustrations. Every attempt has been made to establish a copyright owner for these illustrations. However, if I have inadvertently used copyright material without permission, I apologise and will make the necessary correction at the first opportunity.

Finally, I am grateful to my husband, Mike, for once again providing first-class, critical proofreading skills.